SEASCAPE
PAINTING
STEP-BY-STEP

A REVISED AND ENLARGED EDITION OF THE TECHNIQUE OF SEASCAPE PAINTING

SEASCAPE PAINTING
STEP-BY-STEP

by Borlase Smart

WATSON-GUPTILL PUBLICATIONS/NEW YORK
PITMAN PUBLISHING/LONDON

First published 1969 in the United States and Canada by Watson-Guptill Publications,
a division of Billboard Publications, Inc.,
1515 Broadway, New York, N.Y. 10036

Published by special arrangement with Pitman Publishing Ltd., 39 Parker Street,
London WC2B 5PB, whose *The Technique of Seascape Painting*, © Mrs. Irene Smart, 1965,
furnished the basic text for this volume.
ISBN 273-01275-4 Pbk.

Library of Congress Catalog Card Number: 70-82748
ISBN 0-8230-4741-5 Pbk.

Manufactured in U.S.A.

Paperback Edition
 First Printing, 1978

FOREWORD

As a foreword to this volume by Borlase Smart, how am I to express in words my admiration for his temerity in placing before us a treatise on the most difficult and complicated task that ever beset a painter?

For one whose heart draws him to the sea must, in the first place, have an exceptionally retentive memory, and be able to grasp in a few moments the effect of the ever changing movements of the sea and sky; he must have a delicate and subtle sense of color, and have the ability to place the main features of his impression of the subject on the canvas with few strokes of the brush; and, beside this, he must be prepared to face a brave fight with the elements, which will be frequently against him.

These qualities, which Borlase Smart has proved himself to possess, have enabled him to give to artists and to students a book which is full of help and advice, accompanied by excellent, interesting, and instructive illustrations.

He has lived and studied for a number of years at St. Ives on the exposed and rocky coast of Cornwall, where the Atlantic rollers surge in stately procession, and he has become imbued with the spirit and power of the sea. He has given us the onward sweep and rebound of waves from rock and headland, and the more gentle movement of shallow water over sand and shingle. He has given us many of the thousand forms of moving water, the curves of ripples and eddies, the network of lashed foam—all these only observed for a moment before the effect seized has completely passed away.

The whole book abounds in useful hints to students and lovers of the sea, and no one can be more fitted for his task of love and labor than Borlase Smart.

Julius Olsson, R.A., P.R.O.I.

PREFACE

I hope this book will be of service to the serious student of the sea and to those who have found the subject confusing.

I base the whole text on oil painting as the medium. I feel that the sea, with all its dignity and power, can be best expressed in this bolder method of work. There seems to be a sympathy between the subject and its translation in this medium.

This does not raise any point of selfish consideration, as I have tried the methods of oil and watercolor, and place the result before the reader.

It will be found that the finest works of sea painters, past and present, are in oils. I have often wondered what the effect of a pure watercolor of the sea would look like, painted to the size of some of the masterpieces in this subject, which have reached measurements of over 6' x 4'.

The color plates are based on varying aspects of sea and coast; in most cases, they are the same size as the originals, in order to emphasize the method of procedure as simply and clearly as possible. The illustrations have been chosen for their technical and analytical value and, in the main, are kept simple in painting for that very reason. I might also add that no attempt has been made to give the illustrations "professional polish."

It will be found that I repeat my advice occasionally throughout the text. It is often just as well to keep on reminding students of certain technical points, and of the importance I attach to them in my endeavor to help them.

It is astonishing how very few real, consistent sea painters there have been in art history. And this applies particularly to contemporary artists. When I say real sea painters, I allude to those who confine their works solely to sea and coast, without the introduction of incidents of shipping or of figure. The true seascape artists, past and present, can be almost reckoned on the fingers of one hand.

When a seascape picture calls for the addition of incident to make up for its apparent emptiness, it proves that there has not been enough convincing sea interest in the work. It is lacking in observation, color, form, composition, and the study of sea phenomena necessary to its completeness.

Sea painting is not an easy subject. The element is ever restless and changing, and commands quick observation. Direct painting is necessary.

A well known artist, giving advice to a student, remarked: "Don't hesitate, but splash." The simile sounds humorous if I apply it to sea painting, but the criticism hits off the idea perfectly. The first two lines of a sea song, however, I think convey more of the general ideal to be aimed at by the student. It runs:

> *The sea, the sea, the open sea,*
> *The blue, the fresh, the ever free.*

This phrasing is applicable to a good sea picture, and suggests that the work should be colorful, pure in expressive painting, and the whole executed with a freedom of handling consistent with the subject.

The serious young artist has to guard against being satisfied with a "pretty pretty" type of work—the sort of picture that is "cooked up" from memory with false tints. This may please the eye of the uninitiated, but it has no regard to truth of tone or form.

The sea and coast are at all times dignified and big in spaces. They should be studied with continued, serious application.

Borlase Smart

CONTENTS

COLOR PLATES
AND DRAWINGS

SEASCAPE PAINTING
STEP-BY-STEP

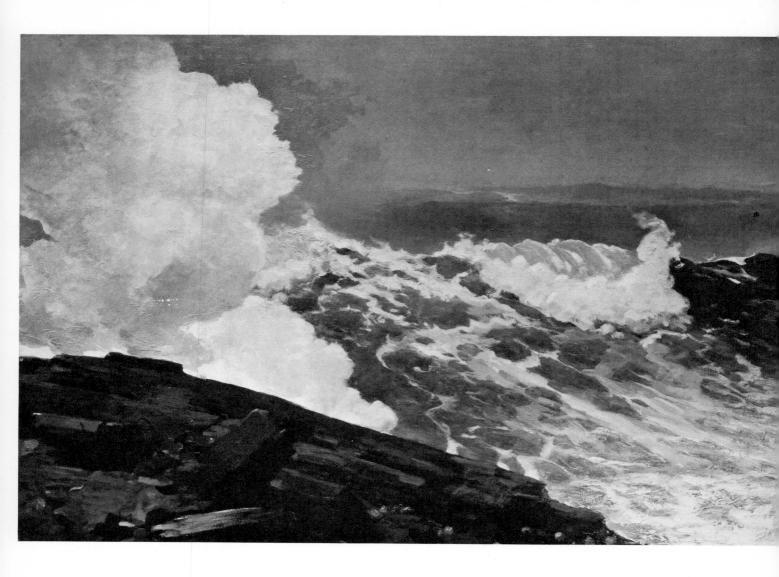

NORTHEASTER by Winslow Homer, 34⅜″ x 50¼″. America's greatest seascape painter always avoided complex compositions, emphasizing that he needed no more than one or two waves and perhaps just a single rock for a successful painting. In this famous seascape, the artist restricted himself to a single slant of rock in the lower left hand corner, painted with long, rough strokes that echoed the texture of the stone. A single rock form juts upward, pointing the eye to the crest of the breaking wave. The wave, itself, is painted as a single, slanting form, with trails of foam carrying the eye up to the point where the wave is just beginning to break. Note how two distant waves are indicated with the greatest economy of means: each is nothing more than a plane of gray, disappearing into the atmosphere. The two distant waves are carefully graded from dark at the top to somewhat lighter at the bottom, thus indicating the concavity of the form; but they are low in contrast, thus avoiding any possible competition with the dominant wave which is the focal point of the picture. Homer visualized every form as three dimensional; not only are the rocks modeled in distinct planes of light and shadow, but the great cloud of foam to the left is gradated from dark to light to dark again, giving it roundness and substance. (*Metropolitan Museum of Art, Gift of George A. Hearn, 1910*)

1

STUDYING WAVE FORMS AND WAVE MOVEMENTS

First of all, I want to analyze a wave form to give you an idea of its action.

The colored diagram of wave movement (Plate II) is designed to emphasize the successive stages of movement and what you should note.

The part of the diagram labeled No. 1 shows the well known Greek wave pattern—the simplest and most expressive drawing in the world of a breaking wave.

WAVE FORMS

Consider a wave moving toward the shore (No. 2). The weight behind it carries it forward until it reaches that point of shallow water where the influence of the beach causes the top of the wave to fall over (No. 3). It seems as if the weight of water, in falling, imprisons the air, which instantly expands (No. 4), and breaks the wave top into foam. The movement continues forward, but a wake is left behind, partly caused by a blow back of the force (No. 5). It is this formation or wake that is so complete a contrast to the parallel lines of shore breakers. It adds movement to the picture.

This will be seen in the next picture (Plate III), which shows shallow waves breaking on a flat beach. The perspective of their wakes contributes a share in the forward movement of the breakers. The tumbling foam catches the full side light of the sun, while the wake, which is of a lower level, mirrors the sky tone. You will notice, when you check this for yourself on the spot, that this wake has a calming influence on its particular patch of water between the breakers. This provides a valuable contrast to the tumble of the foam.

Note also the rush back of a receding wave after it has rebounded from a rock and meets an oncoming one. When this happens, it is like two waves breaking in opposite directions. The rush back meets the oncoming breaker, the top of which is forced up in a mass of broken water and foam. The colored illustration of this effect (Plate IV) is descriptive of such an incident. In spite of the problem of depicting two such opposing forces, I have tried to retain the individuality of the movement of each mass, to give you some impression of this battle of the elements.

MAKING STUDIES

As a preliminary to any actual painting, I should advise you to go out of doors with several sheets of thick brown wrapping paper, or some dark toned drawing paper, cut down to about 14″ × 10″ in size, and pinned to a board. Also take a black crayon and a stick of white chalk. Instead of a pocket knife, use an old safety razor blade. It provides a perfect cutting edge for chalk and crayon. One edge of this type of blade is usually blunted and thickened, and the blade can be used quite easily and safely. It should be carried in an ordinary matchbox. The pocket knife, if not kept sharp, is apt to drag the crayon out of the wood, or sharpen the white chalk badly. It is just as well to have a responsive medium.

The general characteristics of wave form and the outline and shadows of rocks are drawn with the crayon. The white chalk (cut chisel-edged) is a quick and expressive medium for touching in the masses and the tracery of the foam pattern.

Plate V shows a study on brown paper of the forward movement of shallow waves breaking on a flat beach, sketched from the cliff edge. The viewpoint enabled me to note the whole formation. The creeping pattern of foam suggested the appearance of lacework. The small sketch in the right bottom corner is the first rough outline of the main pattern shown immediately above.

Plate VI is a study of the end of the movement. There is just a suspicion of activity in the top right hand one. The larger mass of foam is quietly swirling in a slight depression of the sand before dispersing. The pattern of lacework remains, but the force that projected the wave is exhausted. The two small notes at the bottom show how the main lines were blocked in first.

WORK RAPIDLY

Try to get accustomed to drawing the general idea in black and white almost as fast as a wave moves or breaks. You will obtain more motion in your work. It will express something. No two waves break alike, but there is a similarity.

Try to grasp the idea with a continuous series of almost shorthand notes. Note the movement of one bit at a time and put it down on paper instantly before you become confused with the incidents of other forms moving in quick succession.

Plate VII gives an impression of the added strength in the forward movement of foam from a heavier breaker. There is more volume because the flow-in is deeper, and has the initial force behind it. On a flat beach, this tidal action would travel a considerable distance. Note the design of the pattern again, with its definite lines of movement.

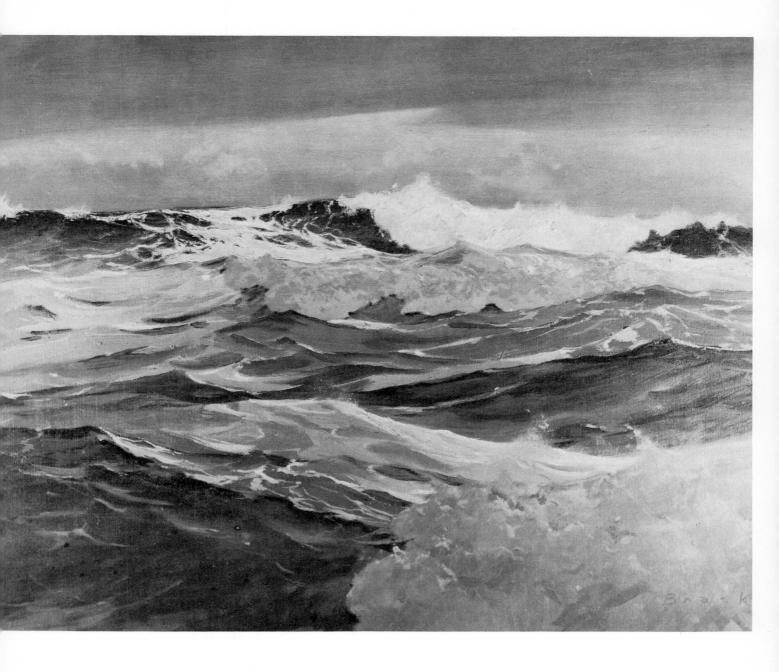

OUTER SURF by Rockwell Brank. The solution to this difficult problem in open sea painting is to place the dominant wave directly on the horizon. The foreground waves tilt diagonally from right and left and lead the eye in a zigzag path to the breaking wave on the horizon. At this center of interest, the tonal contrast is strongest: the foam is lightest and the water is darkest. Although there are patches of foam in the foreground, the artist has minimized these by veiling them in shadow—presumably cloud shadows cast upon the sea.

Thus, the only patch of really light foam is on the dominant wave. Because of the complexity of the wave action, the artist has wisely decided to keep the sky simple, barely more than two tones of gray with a few hints of cloud. Notice, too, that the greatest impasto (that is, the thickest paint) is applied to the foam of the breaking wave on the horizon. The foreground waves are painted more thinly, with more fluid paint. *(Courtesy, Grand Central Art Galleries, Inc., New York).*

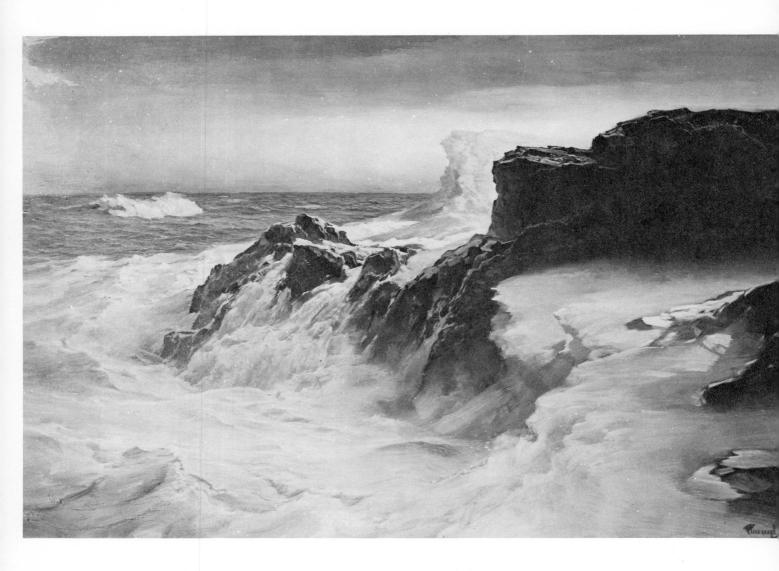

MARCH—NORTH ATLANTIC by Frederick J. Waugh. The drama of this composition derives from the contrast of the dark rock formation and the snowy white foam. The rocks catch the light from above and are, therefore, simply edged with light strokes, plunging into darkness the sides of the rock formation that face the viewer. Moving over, around, and through this darkness, the white foam becomes even whiter. It is important to note, however, that the foam is not merely a mass of white paint, but has a distinct sense of pattern and direction, based on the artist's study of nature. In the lower right hand corner, the foam surges over the rocks and assumes a form which reflects the shape of the rocks beneath. In the same way, the foam pours back down from the rocks in the center of the painting, breaking into channels that are determined by the cracks and crevices of the stony forms. The foam in the center foreground and in the lower left hand corner assumes small, wave-like shapes, as does the foam beyond the rock formation. The thunderous action of the picture is enhanced by the calm of the sky above, which is hardly more than a gradation of tone from dark to light. This contrast of calm and turmoil can be the secret to an effective marine painting. (*Photograph courtesy of* American Artist)

2

COMPOSITION

The lines of design, or the main outlines, are very necessary to the completion of a good study. This is important in regard to composition. The lines of the sea and foam are examples of the finest elements of design, and a successful picture embraces balance, symmetry, growth, movement, massing, and spacing.

CENTER OF INTEREST

Above all, there occurs a center of interest or a focus point of attraction. In any composition, this center of interest should lie inside an ellipse or a circle, according to the shape of the paper, and later on, of the canvas. This space of interest can be kept roughly, say, to about three quarters (or a bit more) of the central part of the picture.

Your drawing, and eventually your painting, should be broader in expression toward the edges. This contributes to a feeling of bigger spacing, and makes your work appear larger in design. Experience will teach you that general all-over detail in a seascape, if carried to the edges of your drawings or paintings, is apt to make your work too photographic.

NATURE COMPOSES ITSELF

One of the amazing things in nature is the way in which the lines of composition are provided—and this applies to sea, coast, and sky especially.

You will find lines of rock formation leading the eye from the foreground to the center of your particular viewpoint. The waves, which always conform to the shape of an object, provide lines of form whose perspective contributes a similar effect.

To make my meaning clear, Plate I has been overdrawn with an ellipse enclosing the actual items of interest. The lines of composition of rock forms, especially where they join larger masses, fall into definite planes of recession, and lead the eye to the focusing point of the picture. Even the roughly suggested breakers contribute to this on the right. The white dotted lines, passing through these main points, are also drawn to prove this, and denote what should be looked for.

This grasp of composition will follow the intensive study—in the preliminary black-and-white chalk stage—which accustoms the eye to form. A perfect seascape is so much dependent on perfect composition that I emphasize this again later in demonstration pictures.

MASTERING FORMS
IN BLACK AND WHITE

It stands to reason that the student's approach to a seascape in oil is retarded by the selection, the mixing, and the painting in of color, to say nothing of the technique of laying on the paint. So do not rush into color until you have mastered the forms first in black and white.

I want to be emphatic about the black and white preliminary work; later, with the experience gained by this method, you will be able to visualize the scene on your canvas when painting out of doors, and before you start work.

Personally, I do not even draw any preliminary shapes with charcoal on a canvas. I just sweep in the main lines of composition with a brush flowing with thin ivory black. I then paint in solidly. This applies not only to small sketches, but to canvases up to 50″ × 40″.

Experience will show you that the effects of the sea change rapidly, and that valuable time is lost by drawing too much on the canvas. The eye becomes tired. You may change your mind during the painting, and alter something you have carefully drawn in. This leads to confusion and loss of time. More important still, your style becomes cramped as you follow shapes you have already drawn, instead of referring to nature and gaining more vitality by direct and spontaneous observation and application. Let your brush do all the drawing in the actual painting.

Watch the bigness of the sea and coast, and your work will respond in *dignity and weight*—the two chief symbols of the sea.

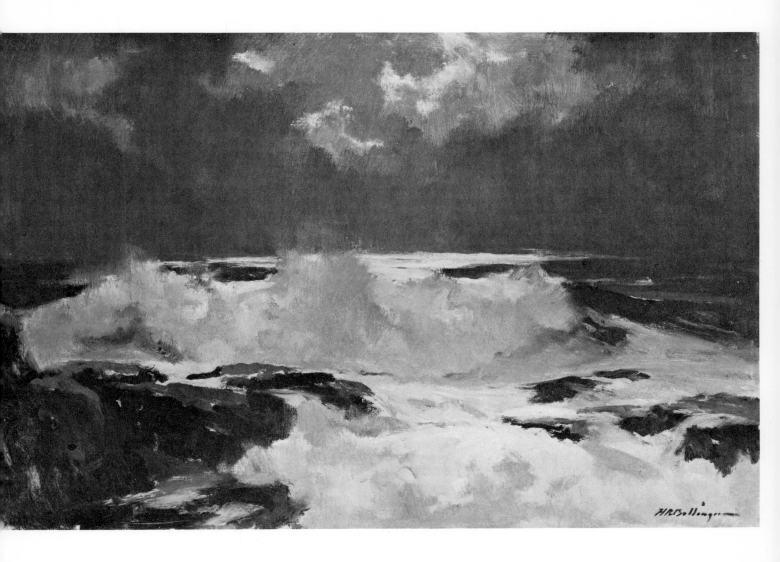

MOONLIGHT by Harry R. Ballinger. The softness and freedom of the artist's brushwork is deceptive, for beneath this apparent simplicity is a very precise knowledge of the forms of rocks, waves, and clouds. The rocks are not mere smudges of color, but reveal lighted top planes and shadowed side planes. The foam, too, is lit from above and behind, with the shadow planes facing the viewer and the lighted planes receiving the moonlight from above. The central wave is particularly interesting because the foam is almost entirely in shadow, silhouetted against a patch of moonlight on the sea behind. Even the clouds are mainly in shadow, just edged with light which suggests the light of the moon, which is just above the canvas and out of sight. There is not a single hard or harsh edge in the painting; all the shapes melt together in the atmosphere, yet retain their individuality as forms, combining softness and precision. *(Reproduced from* Painting Sea and Shore *by Harry R. Ballinger, Watson-Guptill Publications, New York)*

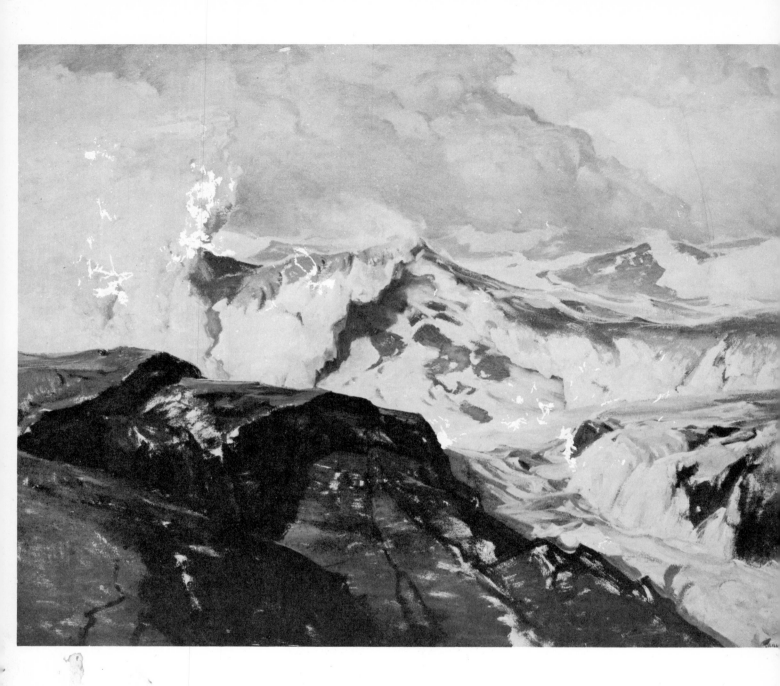

WILD WEATHER by Frederick J. Waugh, 48″ x 60″. The tremendous impact of this composition is a result of the artist's decision to focus on an extreme closeup of a single wave smashing into a single rock mass. The viewer has the impression that the painter had literally set up his easel just a few feet from the point of impact. Obviously, this is unlikely, because the painter and his equipment would be quickly drenched or even washed away. What is more likely is that the artist surveyed the great panorama of sea and shore, then focused his attention on one very small, dramatic detail, much as one might look through the telescopic lens of a camera. The shoreline always offers an enormous range of possibilities and the painter must develop strong powers of selection. One way to begin is to use a viewfinder, which is nothing more than a pocket sized card with a small rectangle cut in it. Look through the viewfinder as you would look through the "eye" of your camera and this will isolate just a few elements on which you can base a painting. Later on, of course, you should develop the ability to select your subject—and eliminate distractions—without the aid of the viewfinder. In this painting, notice how few elements are needed to make a successful seascape: just part of a wave, with part of another wave behind it; just a small section of a rock formation; and one large cloud to echo the wave action. *(Edwin A. Ulrich collection "Wave Crest" on-the-Hudson, Hyde Park, New York)*

3 MATERIALS AND EARLY WORK

Happy is the young artist who can afford the best materials; and it is an appreciable factor that good brushes, good paints, and good canvas contribute their quota to success. Nonetheless, in the very early stages of painting, one can buy cheap, second quality materials which answer their purposes very well.

BRUSHES

I always use flat bristle brushes, as their short bristles contribute a lively crispness in touch. I never use sable hair brushes. They are not "alive" and responsive like the bristles. And above all, do not use small brushes, unless you are painting on tiny panels.

For ordinary work out of doors, say 24″ × 18″, I work with ¾″ to 1″ wide brushes, and larger still in proportion to larger work. This does not mean that I overload the canvas with paint; the big brush conveys a greater sense of dignity and breadth to the work, and also has more covering capacity. It is only natural that later on, when you enlarge up from a small sketch, your brushes should be proportionately larger; for how can you retain the breadth of the original if you do not enlarge your strokes in proportion?

Always clean your brushes at the end of a day's work with soap and *cold* water. Never use turpentine or kerosene for washing. These solvents drive the color into the ferrules, discolor and rot the bristles, and rob the brush of its life.

Do not carry too many brushes in your box. At the same time, do not expect to convey pure color throughout your work if you only use two or three. Keep at least two for rocks, two for sea, and two for sky.

SIMPLICITY IN CHOICE OF COLORS

The important question as to what colors should be used for seascape painting is a vital one.

Here is a short list of those I use invariably: Naples yellow, yellow ochre, raw sienna, rose madder, viridian, cobalt blue, and ivory black; also a very little cadmium yellow for sunsets, and mixed with viridian for the bright greens of cliff grass in direct sunlight. I have found, however, that I can dispense with even the cadmium, as Naples yellow is not so overpowering and is, consequently, more dignified in tone.

Here, I want to give a note of warning. Do not mix too much rose madder in your shadow colors. It is a beautiful pigment when used sparingly, but has a tendency to make grays purple. You will find that purple shadows reduce the quality of light in the sunny portions. I must, of course, add to the list the usual flake white for reducing the power of the colors.

Whatever choice of colors you may make, do not carry unnecessary tubes of paint. Keep to a dignified chosen few, which you will select after some experience and experimenting. The simplest range will be to your advantage as a painter, and more accommodating in regard to the weight

of your sketch box! I have seen students with as many as twenty tubes in a box. What confusion! What a resultant loss of time! What a muddle on the palette! What dirty brushes!

Plate VIII is reproduced from a sketch actually painted in three colors only: cobalt blue, rose madder, and Naples yellow. I chose a fairly dark toned subject to emphasize the possibilities of the power of those combined colors. No flake white was used. The Naples yellow alone was sufficient to reduce the density of color where necessary.

This extreme example of simple color choice should provide a solution to the confusion of the "complete" sketch box of today.

In regard to the lasting quality of the colors you select, I would like to recommend that you study one of the free pamphlets that are issued by well known makers of artists' materials on the permanence of colors. I am afraid that the advice given in these excellent publications is too often neglected, but I urge you, in your own interests, to procure and study a copy.

PALETTE

I have often wondered why so many artists use a dark wood palette. No doubt it is useful if a toned canvas is employed; but, when the utmost purity of color in seascape is a necessity, and your very canvas is white, why mix color on something of a different tone? It is so hard to keep your color pure, even with experienced hands, and especially during continuous work on one subject. I often think the dark palette of mahogany or walnut often supplied in the various sketching boxes, or for studio use, is a contributory factor to a certain muddiness of tone.

The color or "background" of such a palette is in direct contradiction to your canvas.

Color sense, no matter where and how, may become instinctive with experience. But I think the student should approach his goal along the line of the least resistance when dealing with color, and especially in sea painting, for which purity of color is indispensable. I always use a natural wood palette for studio work, and one of white papier mâché or of white wood for outdoor work. White marble, white glass, or a tear-off paper palette also works well in the studio.

SETTING THE PALETTE

Make a ritual of your daily palette discipline. Squeeze out your colors—the lightest on the right, graduating through to black. Train yourself to keep to this order (See Plate IX).

In the early stages, as soon as you find your palette becoming muddled with too many color mixtures, scrape it all off, and start clean again. It is better for your eye. A fussy palette is a dirty one: it amounts to the same thing. Stop painting at once, or your work will respond to its influence.

VITALITY OF PURE COLOR

Do not "tease" your color when creating a tint. Leave it slightly "accidental" after you have obtained the general tone you wish it to be. At least it is pure. Your brushwork on the canvas continues the mixing, but the tint will be more colorful. Don't be misled by the idea that tints for seascape work must be mixed like pots of paint, and well stirred before application.

The accidents of color sometimes constitute a definite charm in a picture. Such tones have more vitality, more carrying power at a distance, and reflect more color light. This applies especially to the sea, rocks, clouds, and sky. Nature is full of such accidents; but they are natural ones.

Do not confuse the source of color life on your palette. Study the color chart in Plate X, which has been designed to give you some idea of the

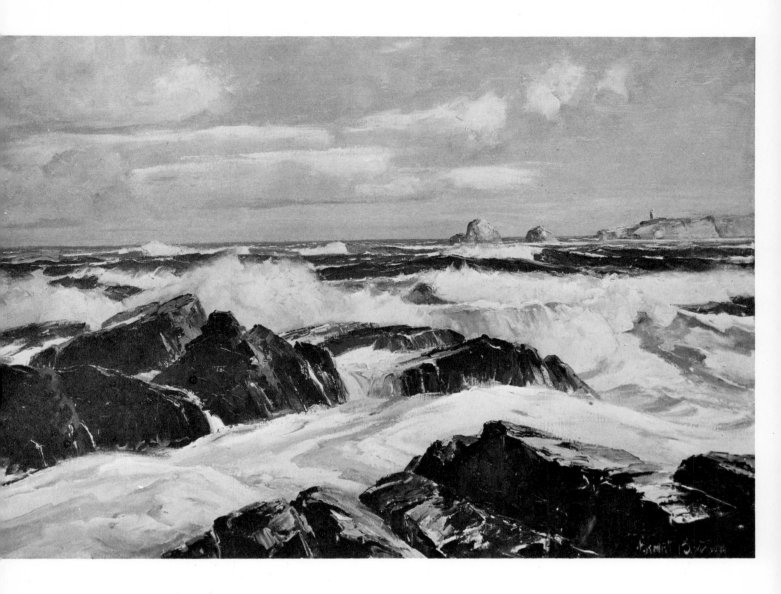

PIEDRAS BLANCAS by Bennett Bradbury. Here is a particularly clear example of the combined use of the palette knife and the brush, with the strokes of each tool following the shapes and movements of the subject. The rocks are painted substantially with the palette knife, while the wave action consists mainly of brushstrokes. Note how the vertical sides of the rock are interpreted with vertical, squarish knife strikes, while the lighted top portions of the rocks are more likely to be horizontal strokes and diagonal strokes. The shadow sides of the rocks are not uniformly dark, but retain the luminosity of wet stone surfaces; the artist applies many strokes of varying densities to suggest light reflected in the shadows. In contrast with the rocks, the rhythmic flow of the waves is interpreted by the softer, curving strokes of the brush, which blends the tones together to produce the subtle light and shade on water and foam. The rounded swells of the water in the foreground are carefully modeled in subtle planes of light and shade to emphasize their three dimensional quality, rather than merely reducing them to a pattern of strokes as the beginning seascape painter tends to do. (Courtesy, Grand Central Art Galleries, Inc., New York)

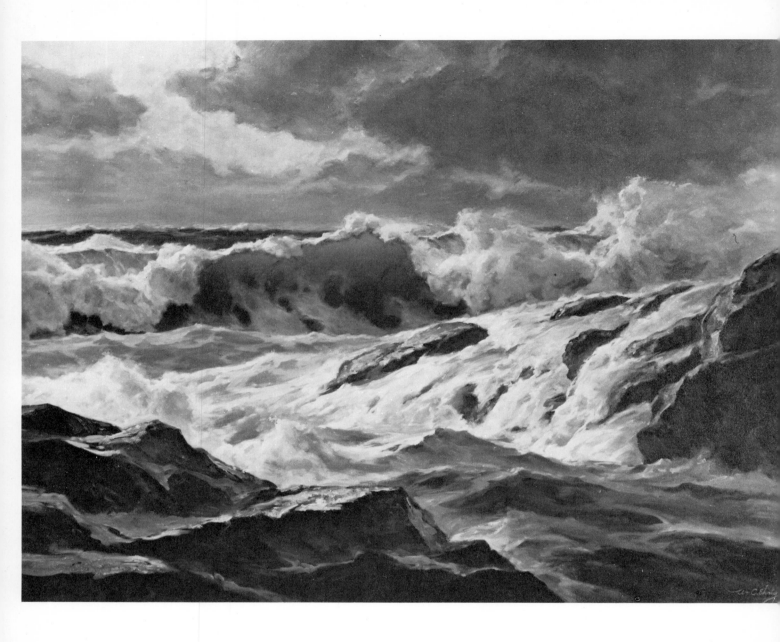

BREAKING SURF by William C. Ehrig. A dark, stormy sky is often most effective when it is employed to contrast with the whiteness of breaking foam. Here the light-tipped edges of the foam are placed against the darkest areas of the clouds, while the one break of light in the clouds points, like an arrow, to the focal point of the picture. The action of water moving over rocks is worth studying with some care. Here we see one wave breaking, while another has already broken and is spilling over the rocks. In the extreme foreground, we see the last evidence of a wave which has already broken and which is beginning to rush backward into the sea. The beginning seascape painter should make many drawings in pencil and chalk—preferably on toned paper so that he can take advantage of light chalk to indicate foam—based on precise observation of waves in various stages of movement. *(Courtesy, Grand Central Art Galleries, Inc., New York)*

analysis of the more important tints used in the various pictures in this book.

It is interesting to note the difference in luminosity between the flat mixed color and the unmixed or accidental tone. The flat examples show comparatively little life, contrasted with the vitality or emotion produced by the accidental ones. The latter, moreover, reflect a greater sense of light. Part of your art education should consist in experimenting on similar lines, working from your personal observation of nature's facts.

In Plate X, No. 1 shows the lay-in tone for the rocks and cliffs. No flake white was used, but a touch of linseed oil was added to insure transparency. In order, the tints are: (1) raw sienna; (2) rose madder; (3) ivory black; (4) the flat tone; and (5) the accidental.

No. 2 is the preliminary for, say, sand: (1) Naples yellow; (2) rose madder; (3) ivory black and a touch of flake white. No oil mixture is needed here.

No. 3 is the first tone for foam or certain cloud shadows: (1) Naples yellow; (2) rose madder; (3) cobalt blue and a little flake white; (4) flat tint; (5) accidental, an important note to study.

No. 4 shows preliminary tints for shadows and certain sky effects in moonlight: (1) Naples yellow; (2) rose madder; (3) viridian; (4) cobalt blue and a touch of flake white.

No. 5 gives first tones for brilliant deep sea effects: (1) rose madder; (2) viridian; (3) cobalt blue, no flake white added. Note the difference between (4) mixed and (5) accidental. This is a very valuable point of interest.

OIL MEDIUM

The only medium I advocate to thin the colors, if required, is a very little linseed oil. Avoid, like the plague, any oil with a varnish mixture, especially when painting seascapes. *Keep all your materials simple.*

CANVAS

For the beginner, the artists' supply store provides a cardboard covered with cheap canvas or with an imitation canvas grained paper. But it is a relief, at a later stage, to proceed to the use of good quality stretched canvas. There is a different feel about it. Even to a professional artist, a proper canvas provides a certain thrill of anticipation, and one starts off with good intentions. Choose a grained canvas for a seascape. Never paint on a smooth surface.

Sometimes a canvas is not white enough for my purpose—it varies quite a lot in tone, according to make and price. I give the surface an additional coating of white lead, mixed to the consistency of thin cream. This provides a most responsive ground to the touch of the brush. Technically, also, it prevents the priming from absorbing too much of the natural oil of the color. Some cheap canvases have a nasty habit of doing this, leaving the color dead and dry. White gesso panels are supplied to fit oil sketching boxes, and these are very useful as well as economical. You can also buy untempered Masonite and treat both sides of the panel with a coating of white lead or acrylic gesso.

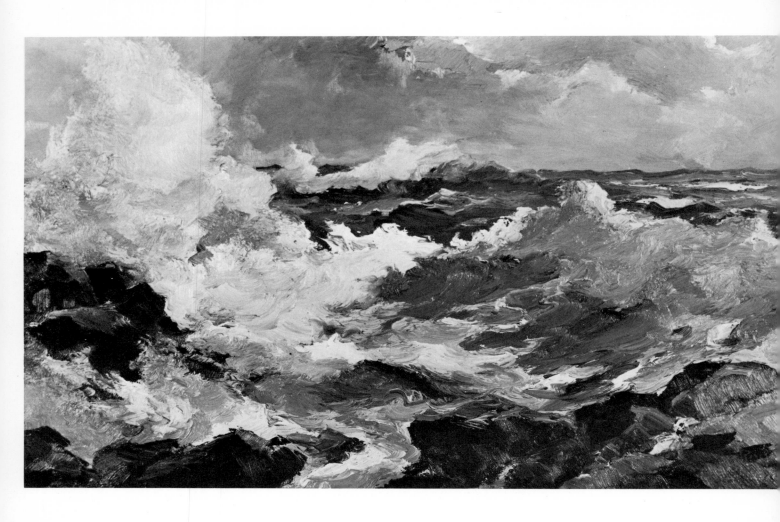

ROUGH WEATHER by Roger Deering. The lively brushwork of this painting catches the vigor of the sea not only in the direction of the strokes, but in the very texture of the paint. The paint is applied thickly, without too much attempt to blend or "iron out" the surface, and thereby detract from the vitality of the total effect. The reader should observe how the swirling water in the foreground is carefully followed by the brush, just as the upward explosion of the foam is followed upward by the strokes. In this kind of painting, where intense emotion is conveyed and the artist gives the impression of having painted in white heat, there is more planning and more cool-headedness than one might suppose. It is too easy for the beginning seascape painter to be carried away by the excitement of thick paint and free brushwork, forgetting to plan the picture beforehand. These seemingly casual strokes must be planned and must follow the forms, based on precise observation of the subject. *(Courtesy, Grand Central Art Galleries, Inc., New York)*

4

TECHNIQUE OF EXPRESSION IN PAINT

No doubt you have heard a pianist described as having brilliant technique. The same term is applied to an artist who is very facile with his brush. He is able to express himself fluently, and in fine style. His work seems to come easy to him, and has a distinct appeal from a mere painting point of view.

The term, brilliant technique, in connection with such a picture sometimes suggests a reserve of expression; but the facile painter goes no further than this technique, or surface painting. There is no solid impression of the real thing underlying the superficial application of clever dexterity. This kind of technique is, however, the saving grace of such a picture. But when brilliancy of method is added to the intimate knowledge of the thing painted, then we have a real work of art.

USE COLOR THINLY
AT FIRST

To the beginner, this question of technique is a natural puzzle, especially when starting in color. Technique arrives with a personality of outlook or expression. It is one's own particular way of telling a story in paint as one develops experience.

The student must, of course, feel his way gradually, until the handling and mixing of color is mastered. But I emphasize the point again—use color thinly in the early stages of a painting. I do not mean that the paint should be so diluted with linseed oil as to make it thin and running. It should not be applied too thick or heavy at first as it leads to complications if you have to alter anything.

RENDERING MOVEMENT
WITH BRUSHSTROKES

You will find, after the initial period is past and you become accustomed to the feel of your medium, that you can create convincing effects by following the actual modeling of nature. Take, for instance, a wave such as the one seen in Plate XI. Watch its makeup carefully, and try to copy the direction of its movement in brushstrokes. In the illustration, I have shown you an analysis of the technique—and have made the strokes or touches clear to emphasize my meaning.

The wave is moving toward you and hurling its foam cap forward too. Paint the movement in your strokes. The sky can be painted with a contrasting flatness. This helps the feeling of the water movement and keeps the sky back. An important feature is the contrasting tone in the reflection of the foam on the water in front of it. This is of a greener tinge than the foam color near the shore and adds to its luminosity and motion. This technique of painting movement is repeated in various forms in Chapter 7 on "Sea Painting." It is such a feature of seascape work that special attention and concentration on your part are necessary to grasp its characteristics. Make plenty of intimate sketches of sea shapes and colors under various effects of lighting.

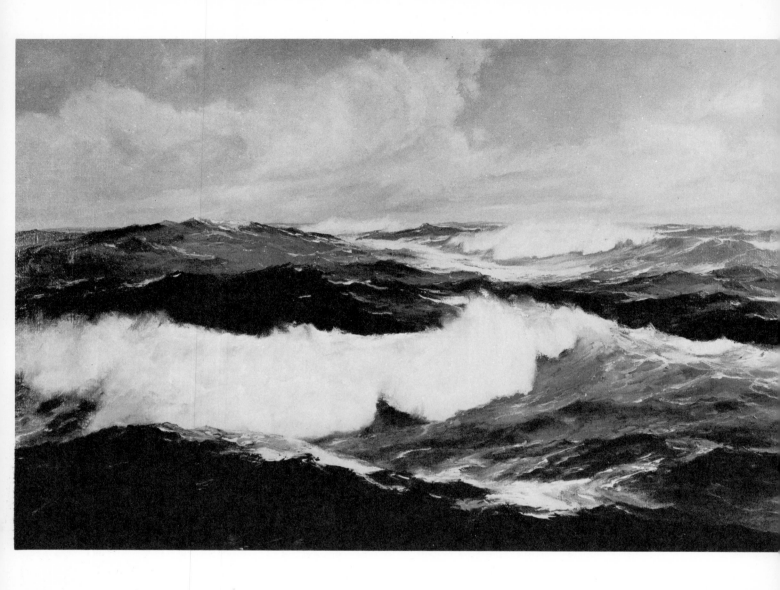

MID-PACIFIC by Bennett Bradbury. In this open sea painting, the center of interest is the breaking wave in the foreground, whose white foam is framed by one dark wave in front and another dark wave behind. This is the area of greatest tonal contrast. The distant waves are grayer, while the distant foam is not nearly as white, and actually melts away into the gray of the sky in order to minimize the importance of the more distant breaking waves. The sea is divided clearly into planes of light and dark: some waves are in darkness while others receive the light, and the appearance is similar to a series of mountain ranges, one behind the other. The artist's method of applying paint is interesting. The surface of the painting not only shows the marks of the brush, but the strokes of the palette knife, and even scratches made by the tip of the knife (or perhaps the end of the brush handle), where the artist has wanted to indicate traces of foam on the dark waves. *(Courtesy, Grand Central Art Galleries, Inc., New York)*

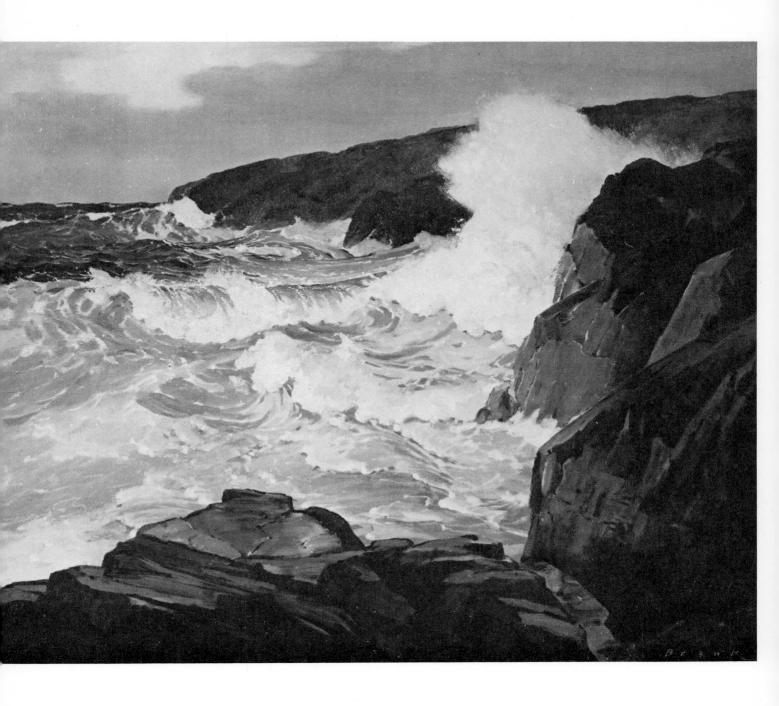

SWELLS FROM THE SEA by Rockwell Brank, 30″ x 36″. The focal point of the picture is the area of greatest contrast, where the whitest, largest patch of foam strikes the dark rocks. The viewer's eye enters the picture through the gap between the rocks in the lower right, travels along the diagonal of the water rushing back from the rocks, then swings along the dominant wave from left to right, and centers on the plume of foam. The brushstrokes carefully follow the form and action of the water. Each stroke is quite visible. Note how the downward curve of the breaking wave is interpreted by short, arc-like strokes which curve downward too. The swirling water in the foreground is rendered in swirling strokes. And the forms of the rocks are rendered with strokes that follow the planes vertically, diagonally, and horizontally. The foreground rocks are rendered in considerable detail, with careful attention to cracks, gaps, planes of light and shade, while the distant rock is painted flatly, with little detail. (*Courtesy, Grand Central Art Galleries, Inc., New York*)

WAVE BREAKING ON A ROCK

Model your strokes or touches to the direction of movement and the form of the foam. The technique of painting the pattern of the foam in Plate XII reflects the actual incidents of cause and effect. The curved side of the rock forces the wave to rebound seaward into the eye of the wind in an arc of almost solid water. The gale blows the less weighty portions into flying sheets of spray. Such an effect should be kept restrained in painting; although it is no unusual sight in rough weather, it is rather too eccentric in design to make it a prominent feature in a picture.

A ROCK OR CLUSTER OF ROCKS

They all have modeling, facets like a precious stone. Copy the direction of these surfaces *as you see them in nature.* You will find that the direction of your brushstrokes contributes, from the very start, a sense of construction or build to your rock forms. They sit on their bases better.

The diagrammatic sketch of rock forms (Plate XIV) illustrates the contributory effect the brush touches have in the buildup of the preliminary stages. The more finished study still retains this, thanks to observation of nature's own technique (Plate XIII).

CLOUDS OVER SEA

These are done in the same manner as foam. Adapt your touches to their particular form (Plate XV). The sky should be flatter in painting than the clouds which float in front of it. This gives the effect of distance behind them.

I painted in all the shadow construction of the clouds first very quickly, while carefully studying their composition and sense of pattern against the sky, and the proportion of sky to cloud. The touches of color emphasized the shapes of the particular cloud forms, and radiated from the center of the sketch, thus giving a big sense of space. The sky was painted next, care being taken to leave correctly shaped portions of raw canvas for the sunlit parts to be touched into.

The eye centers upon the light cloud in the middle, which provides the focus point of the study. Too light or too dark a cloud at the edge of your picture would prove a distracting note, and interfere with the proper balance of light and shade of the work.

HEAVY PAINT

While I am on this question of technique, I want to take you forward somewhat and give you an example of sea painting done in the heavy style. The scene illustrated (Plate XVI), is a preliminary sketch for a very large picture and the note shown in Fig. 1 was my rough lay-in of the important lines of composition.

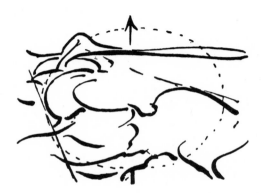

Fig. 1. Main lines of composition in Plate XVI.

You will notice that all the touches of thick paint contribute their share to the expression of the movement of the elements. The color was, in fact, so thick that it was almost modeled to the forms. The size of the completed work was 6′ × 4′, and the bigness of style and method became a matter of course in a canvas of such dimensions. Some of the brushes I used in the large work were 2½″ to 3″ wide. Another factor, too, was the carrying power of such color; that is to say, the effect at a distance. It had a force and weight in technique consistent with the immensity of the sea as I saw it at Land's End. The shadows produced by the thick paint seemed to help the idea.

The danger, however, in painting so thickly is that any retouching done later, far from adding to its quality of freshness, seems to deaden the purity of color. One has to work at top speed and place everything on the canvas in its proper value and leave it "unteased." Needless to say, this kind of painting is of a somewhat strenuous nature on so large a scale, but it was a valuable experience.

The inclusion of this demonstration of so advanced a subject at this point is a sequel to my advice to you not to start work "daubing it on." Wait until experience teaches you how to.

There is nothing more depressing, even to a professional artist, than an accident arising out of a badly painted tone of thick paint, but long experience helps the artist to correct this fault.

PALETTE KNIFE PAINTING

The painting shown in Plate XVII was done entirely with a palette knife.

Some sea painters use the palette knife with its flexible blade as a brush, and certainly obtain much purity of color, and a great liveliness of effect. It is a method, however, that can be used only by the most capable. Even so, in spite of the pure color, one is so conscious of the pigment only, and the flat technique reflects the eccentricity of the instrument. There is nothing so expressive as a good brush, which is part of yourself as you handle it, reflecting the emotion of your mind along your fingers.

THUMB AND FINGER PAINTING

Still another method in foam painting is the use of the thumb and finger to soften the paint for flying spray.

The example (Plate XVIII) was treated by this method, the whole of the foam being "thumbed" in. But here, again, the result reflects the method employed.

I have seen it done with a certain dexterity and good effect. But the result *was* artificial. From a health point of view, one has to be careful of lead poisoning; if the flake white pigment finds its way under the nails or into a cut, unpleasant results may follow.

I mention these trick methods of technique merely as a matter of passing interest. You will, of course, realize that the simplest means are always the best in the end. Nature is big, yet simple, in makeup. Follow her example in your technique.

HANDLING THE BRUSH

Once again in reference to brushes, keep your touch consistently crisp and firm by squeezing out the brush occasionally with a rag when it becomes too loaded with paint. There is a loss of firmness in constructive painting if you lose the brush shape by jabbing the bristles into thick paint.

All your touches or shapes are done with the sensitive flat edge of the brush (Fig. 2). The result of the overloaded brush (Fig. 3) is an objectionable thickening of pigment at the downward end of the brushstroke.

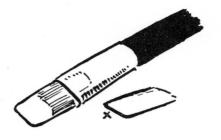

Fig. 2. Crisp, clean, expressive.

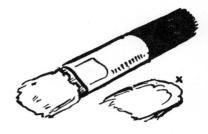

Fig. 3. Crude and distorted.

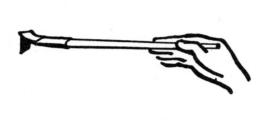

Fig. 4. Keep fingers straight.

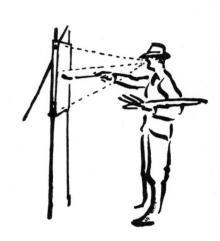

Fig. 5. Hold brush at arm's length.

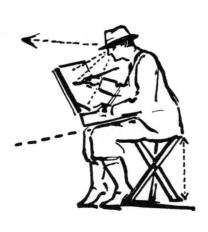

Fig. 6. Bad focus and position.

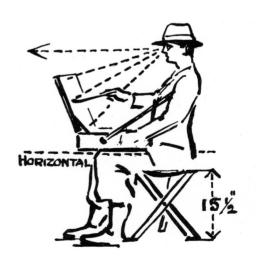

Fig. 7. Good stool height.

Finally, work up to the practice of painting your masses while holding the brush towards the end of the handle (Fig. 4). This keeps your eye away from too close a proximity to your work. You are thus able to focus on all parts of the canvas, and to note the effect of your every touch in relation to the whole.

Standing at an easel, when painting out of doors, I hold the brush as in Fig. 5, but at an arm's length.

YOUR SKETCHING STOOL

Figs. 6 and 7 illustrate an important point in connection with your choice of a sketching stool. There seems to be an extraordinary difficulty in obtaining the correct height for the normal person. Too high a stool (Fig. 6) tends to induce cramp, rounded shoulders, too close proximity to one's work, and a continuous raising of the head to view the subject. I would suggest that you make sure that the height of the stool's legs *when open* is 14″ to 15½″. The correct height, noted in Fig. 7, gives you comfort, a perfect balance, and a good field of vision. Your upright carriage has its reaction on your work.

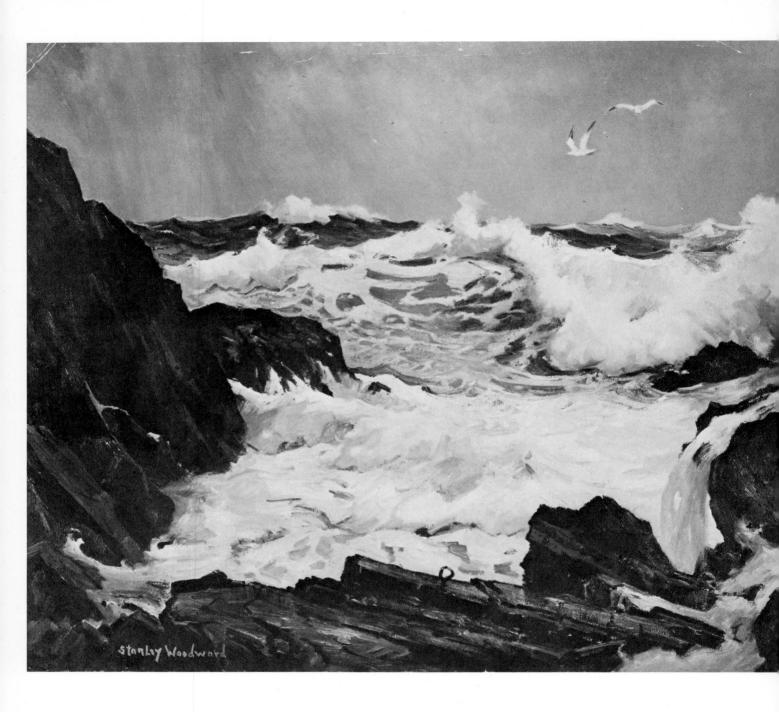

PIGEON COVE SURF by Stanley Woodward, 30″ x 36″. The viewer's eye travels diagonally upward from the lower left hand corner to meet the oncoming wave. The strokes of the brush are distinct and vital; the diagonal rocks in the foreground are interpreted in rough, diagonal strokes; the more vertical rocks to the left are treated in a similar fashion; the dancing foam in the foreground is interpreted in short, lively strokes that change direction as the wavelets move among the rocks; the patches of foam and clear water, on the face of the oncoming wave, swing along the curving plane of the wave; and the strokes of the breaking foam are thrown upward like the foam itself. Observe how a little plume of foam, just off center and breaking across the horizon, is caught by the wind and thrown *abruptly* to the right. (*Reproduced from* Marine Painting *by Stanley Woodward, Watson-Guptill Publications, New York*)

5 COASTAL SUBJECTS DEMONSTRATED

I am now going to give you, under different chapter headings, the essentials of various subjects of seascape work, such as coast scenes, cliffs, shore and sky, the sea, and sunset effects. My aim will be to word my remarks as if I were giving you a personal lesson.

COAST SCENE IN SIDE LIGHT, EARLY MORNING

The first example is a coast scene painted in the side light of an early summer morning (Plate XIX).

I have noted in outline the principal lines of composition (Fig. 8) which I brushed in before starting in color.

You will find, when you go out to nature, that something there strikes you with the feeling that it will make a good study. Don't hesitate, but get right down to it at once before your first impression is confused with something else, apparently better.

Notice that the rocks and lines of the foreground sea lead the eye to the middle of the picture. The clouds travel mainly around the ellipse, and convey a sense of movement. The horizon and the strata of low lying clouds provide lines of strength and support, and link up the masses of composition. The horizon, especially, provides a restful line, in contrast to the movement in the sea and clouds, and growth of rock forms. Note, too, the careful placing of the horizon, one third of the distance up. It would never do to have this cutting your picture in half.

In this case, there as a particularly interesting sky of good cloud forms, giving a feeling of space and aerial perspective to the scheme. The simple masses of the sky contrasted with the apparent detail of the foreground.

Fig. 8. Main compositional lines of Plate XIX.

The technique of the cloud forms in this particular picture is explained in detail in Chapter 4 on "Technique of Expression in Paint."

The lighting in this picture is of interest. The highlight of the work is the foreground foam. The next in order of brilliancy is the breaker off the shore. From these, the middle cloud provides the third note of luminosity. The eye is thus kept to the central part of the scene. There is no wandering interest produced by unequal and distracting lighting. The clouds and the sky are full of proportional light, but the brilliancy of the foreground foam makes them dull by comparison. Holding a white piece of paper up against the foam and clouds will help you under similar conditions out of doors.

Plate XX is a study I did on brown paper of the rocks on the left, with particular reference to the overflow of the sea pools after flooding by a breaking wave. This was a difficult bit to paint, so I was glad I had accustomed my eye to its pictorial possibilities in this jotting. If something of interest strikes you with a fresh note, jot it down at once before the effect (the tide in this case) alters. You will notice that I have added touches of colored chalk, local to the scene, as a further memory aid. I also did this in the second study on toned paper (Plate XXI) to catch the character of movement and line of composition before the tide rose too high.

This additional note of color on your paper will retain your interest and add variety to the preliminary black and white stage as you gain experience.

The preliminary blocked in composition in Fig. 9 and the sketch in Plate XXII may provide a helpful suggestion about where you find the main lines of rock forms running along the picture. To prevent such bold outlines from leading the interest out of the scene to the left (in this case), the highlight of a breaking wave occupies the central portion at the top of the main rock form. This keynote focuses the eye and provides a solution to the problem of such lateral growth in rock forms. The arrows emphasize the direction of the various tidal movements. These provide their proper contrast to the rock forms and strengthen the composition, especially as their main lines lead the eye from all points to the center of the work.

The analysis of the big mass of foam (Plate XXIII) is given to show, once more, the direction of brushstrokes necessary when the forward movement is of such value. Being the center of interest too, this foam must be interesting in character.

Fig. 9. Main compositional lines of Plate XXII.

As a contrast, take notice of the preliminary blocking in (Fig. 10) of the next picture (Plate XXIV). This is a high angle, semi-panoramic view of the Cornish coast. Observe the sea level of the distant bay on the right. The skyline is only one sixth from the canvas top. The whole coastline was pictorial. There were no clouds at the time and, in any case, they would have been superfluous with such a lot of interest below. This picture is purposely left unfinished. The foreground rocks are just constructionally laid in with their particular "accidental" first color tones, gradually accentuating in building up towards the central portions of the scene. This helped me to realize how much to add in strength of color or detail—more particularly how *little* to add.

In a scene of this kind, nature is the finest teacher. The simple foreground is there for you. But you must *see* it, and realize the essentials relative to its simplicity of translation.

What struck me when I arrived on the spot was the highlight of interest in the lines of foam being drawn out by tidal action from between the rocks. Although it proved to be a lasting effect, and I was able to paint it in direct, I made sure of this vital bit with a study on brown paper (Plate XXV).

See how the perspective of the foam leads you to the center of the cliff forms, and even the mountain at the back emphasizes the focus point.

Fig. 10. Main compositional lines of Plate XXIV.

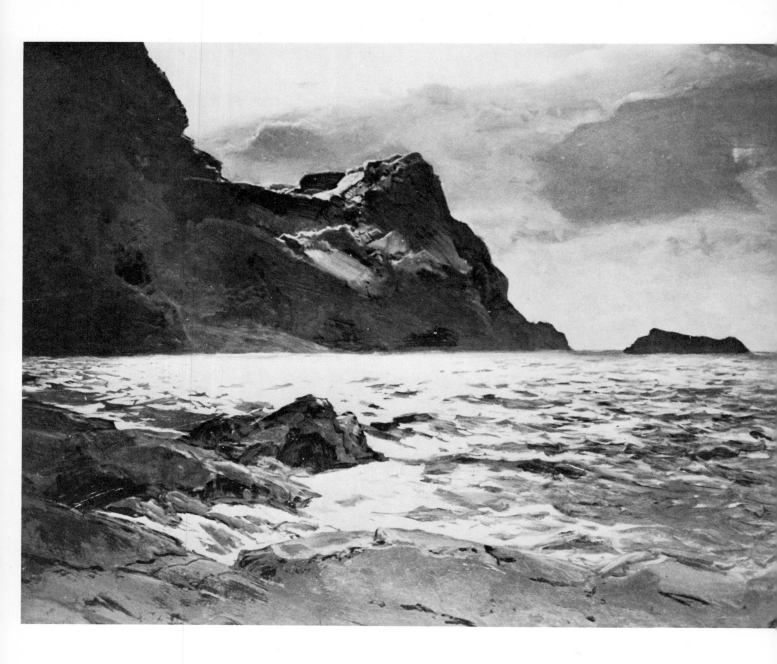

STARK HEADLANDS by Frederick J. Waugh, 30″ x 40″. Cliffs and headlands are splendid coastline scenery for the seascape painter. But it is important to allow the massive rocky shape to dominate the composition; there should be no elements that compete for the viewer's attention. Here, the bold form of the headland seizes the eye completely for several reasons. First, there are no other large shapes in the picture; the foreground rocks are small, there are no large wave forms, and the scale of the headland is emphasized by the small, flat rock on the horizon to the right. Second, the artist has been extremely selective about detail and finish: except for the lighted portion of the headland, the rest of the rock formations are treated quite roughly, with a minimum of detail, and appear almost unfinished. Third, the lighting controls the path of the viewer's eye completely: the pattern of light breaks across the sea in such a way that the viewer's eye is led directly up the center of the picture to the lighted portion of the headland, which is back-lit to stress the handsome silhouette. Fourth, the surge of the clouds leads diagonally into the focal point of the picture. (Edwin A. Ulrich Collection, "Wave Crest" on-the-Hudson, Hyde Park, New York)

6 CLIFFS AND ROCKS

There is an aspect of the coast that provides a dignified composition in the closeup pictures of cliffs. These intimate subjects are full of character. It would be as well for you to choose a sunny day, as the shadows form an important item of cliff architecture, and emphasize the dignity and atmosphere of construction and distance. They provide you with a simplicity of massing, and, if their edges are studied and carefully copied, your very first lay-in with color will give you the keynote of your work, as the effect of the first lay-in will convey.

CLOSE-UP OF CLIFFS

In this picture (Plates XXVI, XXVII, and XXVIII) I had to paint quickly. I was facing south and, as the sun moved, the shapes of the shadows altered, as they always do. There is always a reflected light in cliff shadows from sky and sea, and it imparts a bloom to them. The shadows are not black, but are full of color.

Fig. 11 shows the composing lines in black outline. The patch of sea at the bottom is just enough to add a foundation to the cliffs. The elliptical swinging curve of the main cliff forms, and the lines of rock pattern, are of special importance here. They lead you to the center of forms from all parts of the picture. The perpendicular planes provide the necessary touch of strength and relief to the curved lines and perspective of rock forms. The tiny stream falling over the cliff in the middle gives a vital sense of size to the scene.

Fig. 11. Main compositional lines of Plate XXVI.

I painted this scene in three stages. In my hurry and anxiety to lay in the complete shadow construction and get the bulk of the masses and their weight suggested (working against time and the altering shadow outlines), I over-painted some of the important rock shapes and altered their character. This will be seen in the second stage, where an element of clumsiness is apparent (Plate XXVII). Reconstruction was necessary on those parts (Plate XXVIII). This involves certain drawbacks, as in painting over the under color, one is apt to lessen the vitality and quality of that particular tone. In this case, too, my color was rather thickly painted in. You will remember my previous advice on this point.

WORKING AGAINST TIME

Of course you will find it difficult to retain the first impression any scene makes upon you. The effort of painting, the changing light and color, the whole movement of nature going on all around you, added to your natural anxiety to make a good record, should teach you to work quickly. This is essential in a seascape. You must work up gradually to this method of quick translation.

But at first it must be a patient application of the motto, "slow but sure." The point is that the eye becomes tuned to the details inside the big masses as your work proceeds, and experience will help you to realize when to "jump off" and leave this superfluous creeping in of detail to the imagination. If you respond to the temptation to place too much of this unfolding detail on record, the result will be a lessening of the very dignity and bulk which struck you at first, and which inspired your attempt. Do not forget that the eye takes in the outlines of light and shade, and if the shadow construction is good, all things being considered, the detail inside those masses can be assumed.

I include *Neave Island* (Plate XXIX) to emphasize the method of working quickly. It was painted in one and a half hours, and it contains all the essentials of composition and shadow construction.

Rapidity is to be gained only with experience, and will evolve by itself with the knowledge gained by careful, serious study. The quickness of the example illustrated is the result of such experience. At first, rapidity of work may lead you to become indefinite and sketchy, and your work will look unfinished.

The drawing in Plate XXX, done on toned paper, emphasizes the constructional manner in which you should build up a quick sketch in black and white chalk. It reflects the big masses of cliff outline, and is a helpful note for reference.

LIGHTING ON CLIFFS

I have illustrated two phases of the same scene of autumn on the cliffs under Bolt Head, Salcombe, South Devon.

The first study was made at the wrong time of day. In the previous chapter, I touched on the fact that I was facing south, and upon the consequent quick change of light and shade. The pictures shown in Plates XXXI and XXXII were painted on the south coast of England. Plate XXXI is a sketch made under an "all-over" lighting. The time was early evening, before the true values of the influence of the setting sun materialized. This equal light on all parts contributed certain difficulties in transcription. It also produced an all-over interest of color.

The roughed-in outline in Fig. 12 shows that the scheme is incorrect even in composition and viewpoint. I have numbered the series of repetitions of similar formations of cliff. The design is bad.

The whole sketch reflects a lack of vitality and character, and has been

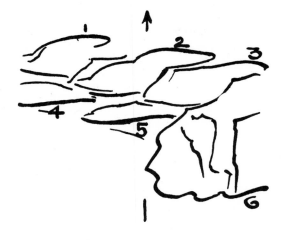

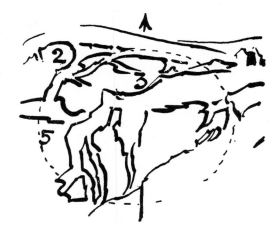

Fig. 12. *Main compositional lines of Plate XXXI.* Fig. 13. *Main compositional lines of Plate XXXII.*

left untouched to illustrate my point. It approaches that dangerous stage when, rtaher than throw it aside, one may be guilty of faking it up in the studio. Such an attempt leads to "prettiness" because there was not enough inspiration and information in it from the beginning.

In the second study, character is emphasized by proper lighting at the right time of day. Plate XXXII is the preliminary of the final picture. The improvement is seen at once. There is more dignity even in this outline composition. I have concentrated on the main cliff form.

In the color reproduction, you see the scene under the proper lighting conditions necessary to its particular topography. The effect of autumn is even emphasized under the glow of sunset on the cliff land. The whole picture has deepened in tone. The light and shade are more inspiring. The peep of sea below, though limited in area compared with Plate XXXI, provides a platform of complementary color to the cliffs above.

The inclusion of the little ruined cable house on the right adds a touch of solitude to the scene, without asserting itself too obviously.

These two pictures were painted from the same viewpoint.

If possible, it is worth your while to observe the subjects you choose under varying conditions, so that your final work reflects their finest characteristics.

The colors used in the second picture were Naples yellow, raw sienna, rose madder, viridian, ivory black, and a little flake white.

CENTRALIZING OF LIGHT

Plate XXXIII, with an enlargement of certain features in its composition, was painted on a quiet day with an occasional glint of subdued sunlight. The scene contrasts sharply with a former one of the Zennor Cliffs (Plates XXVI, XXVII, and XXVIII), which face the direct Atlantic weather. The more modest cliffs in Plate XXXIII occupy a less exposed position in St. Ives Bay. I took advantage of a passing touch of sunlight to emphasize the light on the central portion of the near cliff. How important this is to the picture! You can test for yourself by covering this part with your hand. The result is entirely negative, and the scene is devoid of interest.

Fig. 14. Main compositional lines of Plate XXXV.

UNDERWATER ROCKS

In Plate XXXIV, I have painted the peculiar character of the underwater rocks. Their shapes are defined by the movement of the element above them. The ripple of the water feathers their edges in shape with the particular set of the tide. These rocks are painted in with the local color of the cliffs at the water's edge, but much darker in tone, into which are painted touches of viridian, Naples yellow, and ivory black. The transparent water is obtained with the same color, to which a very little flake white is added. This gives the effect of the sandy bottom shining through; to gain the illusion of submerged rocks, a darker tone of the general sea color near them must be painted into your preliminary painting of the rocks.

The bluish ripples, suggesting the tidal movement, were touched in with cobalt blue, ivory black, and flake white. But I had previously left the canvas bare where these came, carefully preserving their shapes when painting in the green of the water. By this method, you can paint in those lights with more precision on the pure canvas. The addition of the ivory black to the blue keeps the effect on the gray blue side, consistent with the sky effect, and adds to the quality of the tone.

PICTORIAL ASPECT OF ISLAND ROCKS

Before leaving incidents arising out of rocky shores, I want to touch on the pictorial aspect of island rocks. Many of these are dotted around the coastline, and, like the one in Plate XXXV, are easily painted from the shore. Their very isolation makes them a perfect subject for a study.

The particular islet in this painting is The Armed Knight, Land's End, Cornwall. I saw this at dawn after a period of extremely rough weather. The composition of the main lines of the great wave forms added dignity to the scene, and the general idea fitted in with the topography of this exposed rock. The upper portion was warmed by a certain amount of sunlight struggling through the storm clouds.

Plate XXXV shows my first attempt, carried out under exceptionally difficult climatic conditions, while I was sheltering under a rock. Quickness of translation was necessary, as the effect proved a very fleeting one. Nor did the wind pressure help matters, as my sketch box was moving all the time. The final result justified my attempt up to a point. A certain amount of the wildness is apparent in this rough note, and the spirit of the sea has been

caught. But in my efforts to secure my data, I have overstressed my statements in the painting of the waves. As you will see, the individuality of the rock is lost in the distracting episode of wave movement. Another important point is that I have emphasized the glow of the dawn too much. It should have been tones lower and, shall I say, less pictorial. These faults lessened the dignity I had hoped for.

Another attempt was indicated. I could tell by experience that the wave forms would retain their character, as there were signs of the gale continuing. I was by no means satisfied with my rock shape. I had lost its particular beauty of form.

The careful chalk drawing done on white paper (Plate XXXVI) and under more sheltered conditions, resulted in a better understanding of the Armed Knight's individuality. You will notice the twist in the upper part. The top left note of construction helped my finished drawing.

Also you can trace the worn feeling in the edges of the main rock forms, where they have been weathered by the action of the elements. I feel that all this care and attention have a definite result in one's final work. By this means, you will make your pictures more "alive."

My next attempt was to convey to the canvas more of the spirit of the scene, the sea formation reiterating the shapes of the first color note. In passing, I must remind you not to let the apex of your rock, of which the sides are fairly symmetrical, take too central a position. It will cut your canvas in half. In this instance, the heaviest part of the rock is to the right of the center.

In the final picture (Plate XXXVII) you will see that the general color scheme is lower in tone. This is consistent with the time and conditions which inspired my attempt. The rock retains its dignity. The sea forms and their color are kept suggestive rather than actual, but the drawing is there just the same. The touch of warmth in the lantern of the Longship's Lighthouse at the back also conveys some idea as to the early hour. If anything, the waves may be a bit too low in tone, but it is a fault that can be easily remedied by retouching with a suspicion of lighter color where necessary. But the lesson I learned in the former sketch taught me to "hold my hand in," and leave a certain amount to the imagination for once.

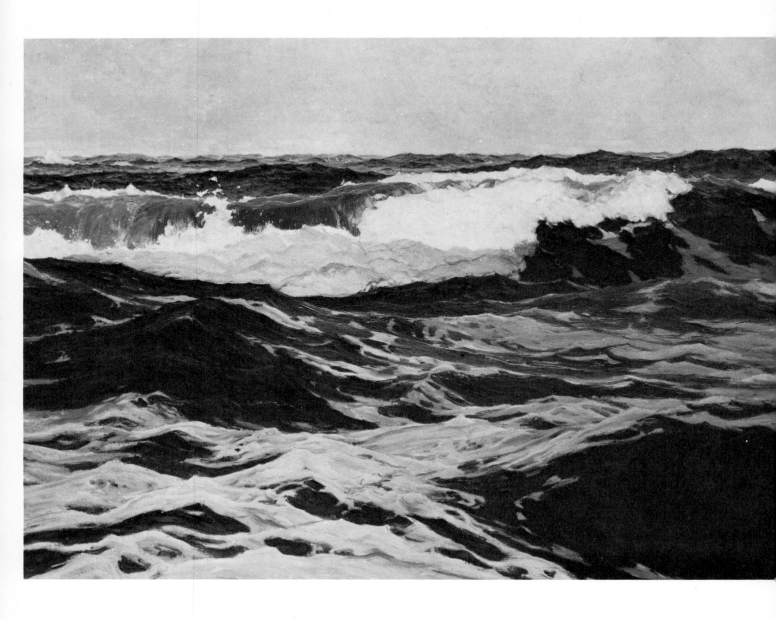

THE OUTER SURF by Frederick J. Waugh, 64″ x 88″. Perhaps the most difficult subject for the seascape painter is a view of the sea itself, without any rock formations around which to build the composition. For the beginning seascape painter, it is difficult to look into the surging mass of water and isolate a few forms that will make an effective composition. Here the artist has solved this problem by focusing attention on a single breaking wave, which bursts into foam, surrounded by a series of less active wave forms. The foreground consists of dark, wedge-shaped waves, between which the white foam zigzags and creates a path that leads the eye to the breaking wave which is the central element in the composition. Beyond the breaking wave are a series of forms, like mountain ranges, receding to the horizon. In this kind of open sea painting, it is often best to visualize the waves as a series of peaks and valleys, surprisingly like mountain ranges, between which the eye is carried to the center of interest. Notice that the sky is kept quite flat and inactive; a complex cloudy sky would add confusion to an already complex interplay of forms. (*Edwin A. Ulrich Collection, "Wave Crest" on-the-Hudson, Hyde Park, New York*)

7

SEA PAINTING

One of the greatest puzzles to the beginner is painting the foam of breaking waves. The general practice seems to be the loading on of flake white. I have seen countless sketches of breakers on a shore with the foam the same tone of white from the foreground to the distance. On a clear day this is impossible, and certainly impossible on a gray one, or how are you to obtain an effect of distance? Hold up a white piece of paper against the breakers and see how the white foam recedes in tone.

PAINTING FOAM

The sketch diagram in Plate XXXVIII gives you an idea of what to look for and note for yourself on the spot. It shows the gradual recession in tone from the highest light on wave No. 1 right through to No. 4. To test the effect, turn the picture upside down and you will find the impression accentuated. The foam takes on the influence of the sky and atmosphere as each wave breaks farther away.

When a wave strikes a rock, the spray that is cast up in the air is not as white as the bulk of the foam in mass. The spray, being shattered by the force of concussion with the rock, has more shadow or color in it from the influence of the sky, or rocks and shore. This is very noticeable on a gray day, when the spray becomes a pinkish tone against the pale viridian of the bigger masses of solid foam (see Plate XXXIX). The second sketch (Plate XL), which was painted in gray weather, reflects this idea. But there was a certain brightness in the sky, suggestive of clearing. The sea, in consequence, was very luminous, and the heavy masses of churned up foam and water, pale green in tone, provided the complementary color in the rose gray of the thick spray.

The next picture (Plate XLI) was also sketched on a gray day, and contrasts with the former study, as it was painted from the edge of a cliff, looking down on the heaving water. The sandy bottom reflected its influencing light in spite of an overcast sky, and conveyed a transparency and depth to the water. The black portions suggest the position of submerged rocks. Here, too, the foam is of a pinky gray color, induced by its green complementary in the sea. The sketch was painted with viridian, very little Naples yellow, a little cobalt blue, ivory black, and flake white.

I mention this palette particularly, as you will notice that I make no mention of rose madder for the pink gray of the foam. I simply mixed ivory black and flake white to the correct tone of those parts. The big green masses produce their complementary color optically, by altering the character of the gray and giving it a pink tint. Rose madder would have made too obvious a tint. By keeping my foam patterns quiet in tone, I convey the sense of distance below my eye, consistent with the actual sea level.

HARD AND SOFT EDGES

Another thing to be studied is the lack of sharp edges to all wave forms. Otherwise, what are you going to do with rocks? There must be a contrast between the two. The rocks show their resistance to the sea. The water,

though enormous in mass, is pliant. Many otherwise good seascapes have been spoiled by a tinny feeling of hardness in the artist's effort to convey form. On the other hand, do not go to the other extreme by making your waves and foam woolly. The top lighting of the sky or clouds enters largely into the perspective and subtleties of sea painting, and helps to create that binding tone of harmony in a perfect picture of the sea.

After I had painted the picture of heavy seas breaking at Land's End (Plate XLII), I felt that there was not enough interest in the foreground to support the big masses of foam at the back. A certain amount of the dark tone helped to relieve the feeling of emptiness in front, but there seemed to be something lacking. It wanted some strong line of composition to fill up this empty ground. I returned to the spot the next day, and noticed a particularly good incident in the recoil movements of succeeding waves, which rebounded from some foreground rocks. They took the shape of small or great curves, according to the projected force, and moved outward in ever widening circles.

I made the sketch of this recoil (shown actual size in Plate XLIII) to familiarize myself with a difficult problem of wave construction.

The roughed in composition (Fig. 15) shows the start of a reconstruction on similar lines to those of my first picture, but with the addition of the lines of recoil to the foreground. Even in the rough-in, you will notice how the big swinging line supports the composition, and adds its note of movement to the general scheme.

In the first lay-in of my second picture (Plate XLIV), you will see more clearly in color the combined effect. The influence of the weight in mass is shown in the great path between the main lines sloping up to the open sea. The big contours of foam are simple in form and painting, and this adds weight to their movement.

I can assure those of my readers who have not yet seen the ocean under such conditions, that the effect of such mighty waves as those falling towards the left of the picture suggests the bursting of a big dam. Their power and weight are so very evident. The main curves must stand out in the actual painting. One is so conscious of the moving masses and not of the small details which make up their planes. Go for the big outlines then.

Fig. 15. Main compositional lines of Plate XLIV.

Get their bigness into your design. They move in dignified procession. There is no choppy rush in a ground swell, and nature gives you time in which to study them as they pass you. Such a pageant of the sea is inspiring and exhilarating, and one will thrill to it. So get it all in your mind while you work hard. Something will happen. You will unconsciously show this power in your painting. During your probationary period, keep everything you do for reference, so that you can note your progress. Your gathering experience will help you to realize and check your mistakes.

There are no tricks in sea painting. There are no shortcuts to success as a sea painter. It is hard work, but it is worth it all. Knowledge is power in the study of it.

OPEN SEA PAINTING

Plate XLVI has certain features of composition and movement, and represents an attempt to paint a real open sea picture. It was sketched from the deck of a liner.

The highlight of the work is the foam capped wave in the middle. From this point, the movement passes along the curve of the swell, and returns through the heaving line up to the left. This is to be seen in the black and white note (Fig. 16). The point of return is emphasized by the arc of the rainbow, which is more dense in color as it approaches the sea. In the first lay-in, the semi-dark wave forms were painted first to emphasize their pattern correctly (Plate XLV).

Cobalt blue and viridian formed the basis of these shapes. No flake white was added. Then came the careful work on the lighter passages, just a shade paler than the key pattern, in order to blend with it and eliminate the effect of hard edges. Into this, and also into some of the bigger dark masses, were touched the reflections of open sky and cloud color. These reflections were much deeper in color than the actual tone of sky and cloud forms in order that the sea should retain its depth and weight. It is surprising how these touches of "top lighting" help the sea to respond in perspective or distance. The sky was painted in last (see Plate XLVI).

The quick sketch (Plate XLVII) of the essentials of weight, construction of foam pattern, and spacing of the masses to help the perspective of the water, was painted in a few colors—Naples yellow, viridian, ivory black, a touch of rose madder, and flake white. Such a simple palette helps the

Fig. 16. Main compositional lines of Plate XLV.

necessary quickness of a similar picture when it is painted from the deck of a vessel. This sketch shows an evening effect off Prawle Point, South Devon. The preliminary painting (Plate XLVIII) shows the constructional composition. The note on tinted paper (Plate XLIX) was done at the same time.

The study on Plate L was done on the heaving deck of the liner *Otranto* in an easterly gale in the Bay of Biscay. The movement of the wash from the vessel's bow, with the wind-blown spray forming a rainbow effect, provided a fascinating subject. An occasional trip in a coastal pleasure steamer is a great help to the sea painter. You view the element from a different angle, and what strikes you at once is the great strength of color away from the land. The different viewpoints of the shore, and any particular cliff interest you may note, should provide opportunities for even pencil or chalk studies of the more impressive features while you are passing them.

The page of jottings of the bold outlines of Handa Island, Sutherland (Plate LI), sketched from a passing motorboat in a fairly rough sea, is the kind of work that helps to quicken the memory at a later period if a background is required for a particular sea picture.

ROCK BACKGROUNDS TO FOREGROUND SEA

In the previous section, I referred to the question of a background cliff as an impressive feature in a sea piece. Fig. 17 is a diagram of the composition brushed in for a picture of heavy seas breaking on the Armed Knight. The inclusion of this rock once again as a feature may add to your interest, insofar as it shows how several subjects may be painted of the same spot from varying viewpoints. Actually, this was painted from my window at Land's End. The preliminary outline repeats my former allusion to the big masses of wave form leading the eye to the point of focus—in this case, the great splash of foam and general sunlit portion at the top of the sketch. You see how this upheaval of foam balances the rock form. The foam takes definite lines of composition, leading the interest around each side of the picture to the rock and waves in sunlight. The great path of simple planes in the middle supports the commotion in the distance.

The first painting (Plate LII) embodies the principles underlying my advice in former chapters, and the whole success of this stage, and its

Fig. 17. Main compositional lines of Plate LII.

degree of encouragement for your final work, lies in most careful observation of the size and shape of the foam pattern in relation to the scene, combined with the application of the pure sea tone to the canvas, care being taken to leave foam shapes pure canvas at this stage. In this case, I painted the big planes of sea in the middle first, leaving the lateral lines blank, and gradually working around the foam pattern with viridian, a touch of Naples yellow, ivory black, cobalt blue, and a little flake white. A touch of rose madder was also introduced when I came to the rock forms.

The explosive effect of the big foam mass was such a study in itself that I painted it separately for reference (Plate LIII). The reproduction gives you an idea of its action and of the touches of paint necessary to its preliminary painting in the final picture. Such a record is essential, especially here, where all the interest lies along the sunlit portion. You gain everything by such research, particularly if the outline conforms to the very balance of form you need.

The final stage (Plate LIV) reveals four distinct planes of sea: (1) the great foreground mass of water, quiet in tone, and half lit through a passing cloud; (2) the bluish tone, which is the shadow of the rock on the sea; (3) the dark gray-green which forces up the tone (4) on the sea and foam in strong side light at the top.

This final painting, from my point of view, possessed all the information necessary to working out a larger picture from it. I was eventually able to do this when I returned from my visit to Land's End. But I did so while the scene was fresh in my mind, and before I had absorbed too much of the atmosphere of "studio work"!

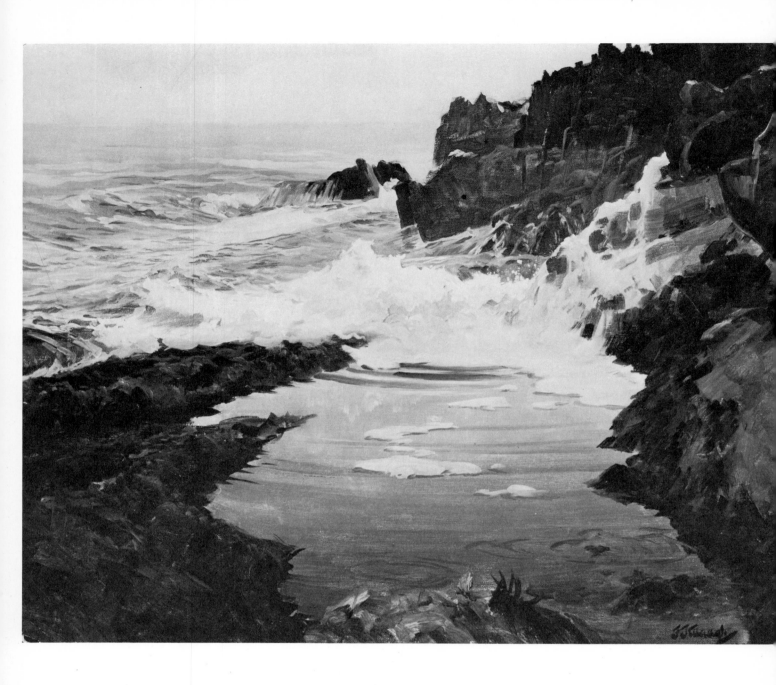

COAST OF MAINE by Frederick J. Waugh, 16½″ x 20½″. The action of the sea is surrounded by the intricate, jagged forms of the cliffs, which frame the breaking water and channel the viewer's eye to the center of interest. Note, in particular, how the low rock formations on the left carry the eye directly to the foam in the center. Here is a particularly interesting coastline phenomenon: the sea breaks across a rock formation which encircles and protects a calm pool in the foreground. Thus, there is an intriguing contrast between the lake-like calm of the surface of the pool and the pounding surf beyond. The distant rock forms deserve particular study and suggest that rock formations all have a personality of their own. In this case, the rocks are not the usual slab-like, blocky forms seen in most seascapes, but are more jagged and vertical, like a cluster of fingers pointing upward. In order to allow the intricate silhouettes of these rocks to assert themselves, the artist has enveloped the sea and sky in a delicate haze far off in the distance. (Edwin A. Ulrich Collection, "Wave Crest" on-the-Hudson, Hyde Park, New York)

8 VARIETY OF FORMATION AND INTEREST

The artist's aim must be to present a picture in which variety is presented in a harmonious whole.

HARMONY OF WHOLE COMPOSITION

When studying a particular effect that you might eventually paint into a complete picture, analyze the parts bit by bit. Every portion is of interest and, as far as nature is concerned, is a perfect picture in itself, so that your final work of importance is a conglomeration of facts individual to the scene as a whole. The completed picture then becomes a harmonious scheme, provided that each unit has been studied under conditions relative to such harmony.

MAIN THEME

Plate LV was drawn in black and white chalk on gray paper. This provided the theme for the picture I wanted to paint. It shows a ground sea at Clodgy, St. Ives. The incidents of forward movement in the big wave on the right of the sketch, and the rebounds from the end rock at the back, and the foreground reef, are complete in themselves. Note the motion in the big wave, caused by the long curve of its outline. This is an illusion arising from the fact that the eye instinctively travels along the main line of an object; this is a most important factor in seascape study. The path of the rebound at the back, and the note of expended force in the final dashes of spray at the top of the rock, focus the interest.

BACKWASH (CAUSE AND EFFECT)

The foreground reef revealed an additional detail as I moved my position farther back.

The next study of this portion (Plate LVI, facing half left) showed me an effect of a backwash pouring seawards from the lower rock forms. The arrows in the right bottom constructional sketch give you an indication of the opposing movements of the rush-back (arrows pointing left) and the gathering force of the rising tide (arrows pointing right). As this is an important note, I have made an analysis of the effect, which gives you some idea of the influence of the submerged rock forms on the shapes of the backwash (Plate LVII).

The rapid motion reveals a hint of the tone of the underwater rocks, and this has been touched in, in the first sketch at the top portion. Such sketches as these are intimate studies, and if you work out your own on similar lines, they will provide you with permanent memory aids to which you can refer continuously.

REBOUND

Plate LVIII is a study in full color of the outward movement of the rebound, a portion of which is suggested in the foreground of my first black and white sketch.

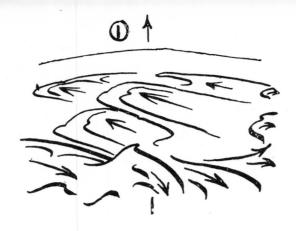

Fig. 18. Diagram of rebound. Plate 19. Sectional diagram of rebound.

The two sketch notes (Figs. 18 and 19) explain this movement. The arrows pointing seaward show the outward force of the projected water, which seems to form a decided layer of its own, superimposed on the top of the heaving tide.

The power of the latter is seen in the reverse motion indicated by arrows along the front. The more powerful influence (shown in the sectional drawing) ends with an upheaval of foam as the undercurrent hits the base of the reef. In the picture, the side light of the sun throws up the foam masses in strong relief, and makes the study much more descriptive. As this movement provided one of the most important features in the complete picture, the color interest is paramount. The method adopted and colors used were:

(1) Dark toned sea was painted first and all light parts were left pure canvas. Cobalt blue, rose madder, and viridian were thinned with linseed oil. No white was used.

(2) Next came the green pattern in the water, viridian and cobalt blue where necessary. White was added occasionally, plus a touch of oil.

(3) Foam shadows were next: cobalt blue, a touch of rose madder, Naples yellow, and a little flake white. No oil was used.

(4) Sunlight on foam was last—Naples yellow, a touch of rose madder and flake white.

HARMONY OF
INCIDENTAL FORMS

The final illustration of this scene shows the gathering of the previous incidents into one harmonious composition (Plate LIX). There must be no distracting note of overstatement in any one particular part. This was purposely painted in tones of cobalt blue to emphasize the character of the lighter parts, which were left pure canvas in this stage. The sketch of the rebound is enough to give you an idea of the general color scheme and harmony of tone. This lay-in was done to show the definite arrangement of form and line, and the importance of leaving your foam shapes defined and helpful, so that when the latter are painted in, the discipline you impose upon yourself by this method leaves no loophole in regard to any indefinite or "faked up" effects.

It is far better even to make an overstatement from nature than to make no statement at all. I have found this lack of definition particularly annoying sometimes when referring to a *study* which did not justify that description in its truest sense. The lack of information in it might lead to an unsuccessful picture. Therefore, I emphasize the point again—get all the facts you can from nature. They are all there for your education, but you must look for them and *see* them.

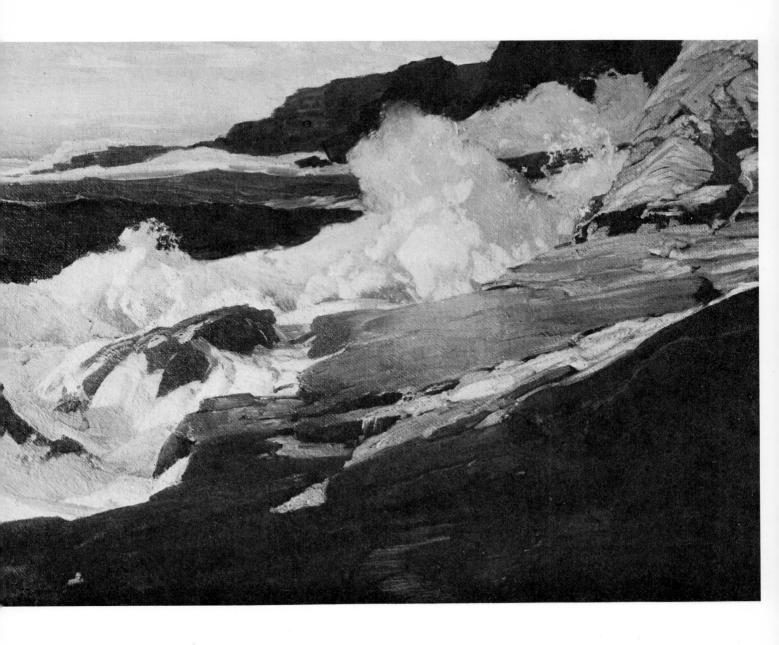

EAST COAST, DOMINICA, B. W. I., by Frederick J. Waugh, 36½″ x 48¼″. The rocks slant diagonally from right to left to meet the oncoming waves. Thus, the strong thrust of the rocks emphasizes their resistance to the hammering of the sea, which surges in from the left. The artist has controlled his lighting to concentrate attention on the center of interest. The rocks in the immediate foreground are in shadow, as are the distant rocky headlands. But an unexpected slant of light illuminates the central patch of rock and the glowing white foam of the exploding wave as it hits the shore. Presumably, the darkness in the foreground is a cast shadow and the seascape painter should remember that cast shadows can be used effectively. Note how the breaking foam on the extreme left is gently de-emphasized by the cast shadow of the rock so that the whiteness of this area does not distract the eye from the central portion of the picture. The artist has also stressed the darkness of the sea and rock shapes beyond the breaking wave in order to make the foam more luminous. (*Courtesy, Los Angeles County Museum, Los Angeles, California*)

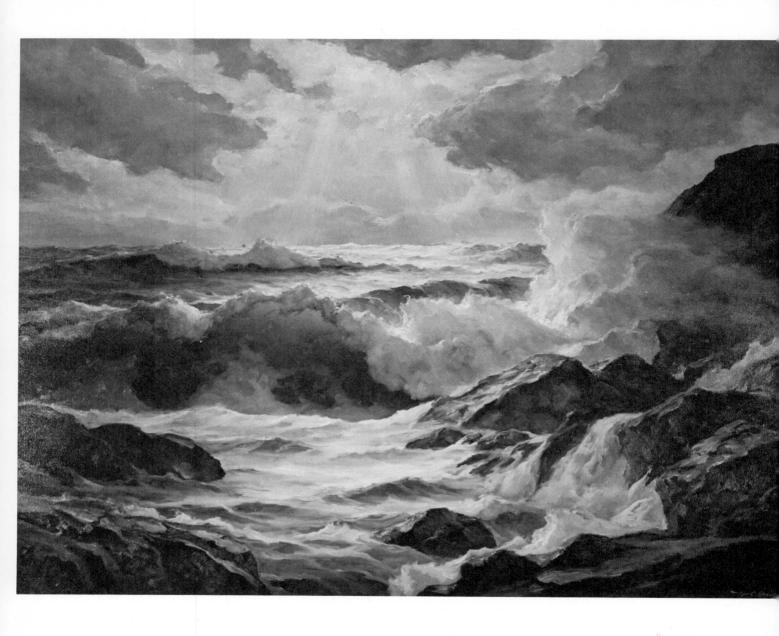

SEA FROLIC by William C. Ehrig. The painter has made quite clear that the light source comes from the rays of the sun breaking through the dark clouds at the top of the picture. The viewer's attention is controlled by the path of light that carries across the sea from the horizon to the central wave and then into the foreground. The light enters the picture from above and behind the central wave, creating an effect of back lighting and top lighting, which is indicated by the delicate touches of light on the crest of the foam. This also places the top planes of the rocks in light and the side planes in shadow. The foam and clouds are modeled in precisely the same way: the upper edges are in light and the sides that face the viewer are in shadow. The painter also reminds us that water is transparent: light is reflected directly through the underside of the breaking wave. *(Courtesy, Grand Central Art Galleries, Inc., New York)*

9 BEACH SCENES AND CLOUDS

Sandy shores have a beauty all their own. The phrase, "golden sands and a blue sky," conjures up colorful prospects of big open spaces. The subject is one, however, that needs to be approached carefully. The very space is suggestive of simplicity in painting. I have seen many a sketch with a lot of empty ground so to speak, which appeared to require filling up with interest. The subject was alluring, but there was no appreciation of composition.

HIGH HORIZON LINE

Note, for instance, a low tide scene with a clear sky (Plate LX). Your sketch may be carried out on these lines: horizon line, one quarter of the way down the picture; the distant breakers carefully painted in, and the utmost purity of color in the sea; the foreground well selected as to sand pools and tidal markings. There will be plenty of them. The receding tide creates these, and it is astonishing what a picture they help you to make, and how flat your beach will look with a feeling of space helped by your high sky line. Your restricted sky does not detract from this.

LOW HORIZON LINE

By way of contrast to this, if your sky has clouds, drop the horizon to three quarters or two thirds down the canvas (Plate LXI). You still retain interest and space. Move nearer the breakers for this composition, to put more character into them, and to support the big sky space. You will find, by practice, that in your preliminary stage, if your brushstrokes respond to the receding planes of the beach, the technique will provide an interest in the painting of it. The same applies to the doming of the sky, a phrase denoting the gradation from the deeper blue tones at the top to the paler ones on the horizon.

CENTRAL HORIZON LINE

A third idea may be attempted. The horizon line is just below the center of the canvas; there is a very flat beach, with big sea pools reflecting the by the sea. The sand marking break the outlines, or the tide causes a move- clouds (Plate LXII). The reflections do not, as a rule, repeat the sky forms ment of some sort that disturbs them. The effect in a sea pool is of a darker tone of color throughout, and this prevents the eye from being distracted by too many equal highlights in sky and shore.

BEACH WITH LANDSCAPE BACKGROUND

As a contrast to the three former scenes, I have illustrated (Plate LXIII) a view looking along a beach from end to end. It is typical of many such formations around the coast, and sometimes, as in the present case, contains a background of a semi-landscape order. This may add to the pictorial qualities of the work. But, at first, care should be taken not to select too complicated a view. To counteract this, move nearer the cliffs abutting on

Fig. 20. Main compositional lines of Plate LXIII.

the shore. They may possibly mask out some of the intricacies of the background.

In the picture, the big mass of Ben Hope is fairly dignified in outline and helps the composition.

Look for the important lines of rhythm and construction as I have shown in Fig. 20.

COLOR

One of the chief reasons why I have included this picture is that there is a certain tint of green in the sky color, which adds quality and light to the tone of the sand. I consider this an important point here. But it does not necessarily follow that it always happens with a beach in full sunlight as this one is. It all depends on the tone color of the sand. In this case, there was a pink note running throughout, and perhaps the climatic conditions helped too. Its complementary (and I have touched on this before) is the tone you see in the sky. You will notice in the preliminary painting (Plate LXIV) that, although I have not toned down the raw canvas on the cloud form and the snow capped mountain, the eye still centers on the main part of the picture—the sandy beach. Again, the perspective of the quiet foam outlines was left raw canvas. Very great care was once more put into the drawing of the cobalt blue around these forms. They are necessary to the true value of the perspective planes of the sand; it must lie flat.

Another point I wish to repeat is in reference to the "accidental" color in the painting of the cliff. This makes the rock mass solid in structure by reason of its technique. The blue effect of the first lay-in (cobalt blue only was used pure from the tube in most parts) reflects the tone of a warm day on the west coast of Scotland, and makes its influence properly felt in the final painting illustrated. The sky was touched in with Naples yellow, cobalt blue, and a little viridian and flake white. With strong sunlight on sand such as this, look carefully to see if there is any reflection from the beach on the shadowed portions of the cliffs. You will find my strongest reflected light in the middle of the cliff line. This adds to the value of the focus point.

CLOUDS OVER SEA

I have a feeling that the sky and clouds over the coast and sea are different in color, and in certain other characteristics, from those over a landscape proper. You could not paint a landscape sky into a seascape work.

Note carefully the shapes of the clouds. They harmonize with the sea according to wind, weather, and general lighting effect. There is more halation by the sea. The clouds are more radiant in tone and color.

I remember painting a sky one day, and carelessly putting in the sea at a later date when the wind was different. A critic pointed out that my sky did not fit my sea. He was right. Any clouds will *not* harmonize with any sea.

I emphasize the fact that in nature, whatever the sky effect, it always balances with the scene. If your picture looks wrong, your lack of experience or observation has made it so. Do not put in clouds of your own making. Get the spirit of the real ones, and if your sketch is uninteresting to the average person, you at least have the merit of trying to paint what you see.

Make lots of sketches in black and white chalk or in color, with a note of the tone of the sea running at the time. The latter is especially important.

The first picture of clouds over the sea in St. Ives Bay (Plate LXV) shows the quiet, restful effect of early summer morning. They are pearly in tone and full of light. The extremely low horizon adds to the space of the sky, and the note of sea color is a useful reference in harmony and contrast.

The second and contrasting picture (Plate LXVI) was painted on the south coast of England at Salcombe. It is significant of the weather conditions prevailing at the time: a stiff breeze, accompanied by thunder-showers. The boisterous nature of the effect is reflected in the liveliness of technique. As I advised previously in the chapter on technique, "adapt your touches of color to their particular form." Also do not forget to paint the sky color *after* your cloud shadows, leaving the pure canvas the proper shape for the light parts.

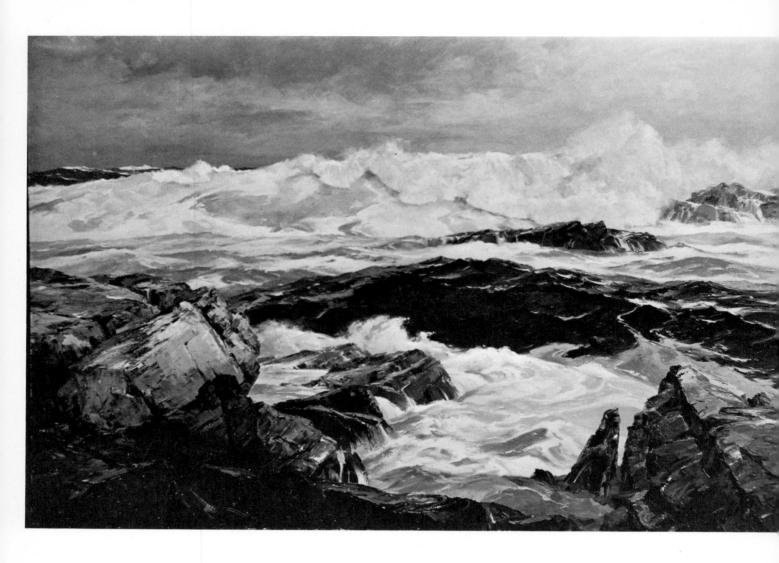

THUNDER REEF by Bennett Bradbury. The foreground rocks are a particularly interesting use of the palette knife. The flat strokes of the knife are particularly appropriate for rendering the planes of light and shade. The pile-up of paint is also a very effective way of rendering the rough texture of the rocks. In painting with the knife, it is particularly important to retain spontaneity and not to go back into the wet paint, "ironing" it out with the brush or stroking the wet paint repeatedly with the palette knife until the fresh color turns to mud. Palette knife painting must be spontaneous and decisive. However, the spontaneity must be planned: before the knife is applied, the artist must visualize his planes of light and shade, as well as his textures, quite clearly. This painting also shows a very effective contrast between the short, flat, geometric strokes of the knife, and the softer, swirling strokes of the brush which render the rhythms of the foam in the central foreground. The dark wave that moves horizontally through the center of the painting also shows the marks of the knife. And it should be added that the knife is particularly appropriate for piling up the luminous whites of foam—provided this is not overdone. *(Courtesy, Grand Central Art Galleries, Inc., New York)*

10 COMPLETE DEMONSTRATION IN FIVE STAGES

Plate LXXI is an effect of sunset glow on wet rocks with a rising tide. It will provide an interesting contrast, in a color sense, to some other illustrations in this book that were painted earlier in the day. It was sketched in three hours, at one sitting.

The glow does not, of course, last that length of time, but the constructional tones were laid-in early in the evening, and the final painting was completed during the height of the effect.

The brushing-in of the main lines (Fig. 21) was done as already described. Again note the lines of rock leading to the breakers and glittering wet rocks. The main line of sea form, and its return curve on the right, reflect the description of a rising tide. They create the movement of a hurrying mass of water.

Fig. 21. Main compositional lines of Plate LXXI.

FIRST COLOR LAY-IN

In Plate LXVII, I blocked in all the half-dark portions of the rocks with raw sienna, rose madder, and ivory black, with a touch of linseed oil occasionally to give the paint a slight transparency and thinness. Care must be taken to follow the shadow outlines with precision. Remember, in the early stages, that you should err to the point of hardness in rock painting in order to get all the information you can get out of nature. Your endeavor is to translate hard facts at first. Later, as experience asserts itself and style is developed, is the time to select the essentials.

The whole idea of this preliminary lay-in is to help you to realize the importance of correct composition before you paint in solidly with actual color. You can, so to speak, visualize the picture in your first tint, and can make any necessary alterations before it is too late. It is certainly a problem, in the early days, to make an alteration after your sketch is finished. My method consists of a gradual building up in progressive stages.

PAINTING LIGHTER PORTIONS OF ROCKS

The next stage (Plate LXVIII) is the painting of the lighter portions of the rocks. I used pure raw sienna, rose madder, and Naples yellow, leaving the highlights pure canvas where the wet parts catch the glitter of light. This is important, as you can paint in similar effects with greater precision on the raw canvas, and with a clean brush, during the last stage. You will find that, in this second painting, much of the original hardness will disappear when you paint to the edges of your first lay-in. Use a fresh brush for the second stage, keeping the other for any retouching necessary. The Naples yellow gives the transparent raw sienna and rose madder more body and covering power.

PAINTING HALF-DARK PORTIONS OF THE SEA

I next painted in the half-dark portions of the sea (Plate LXIX). A clean brush is needed, with viridian, rose madder, and Naples yellow for a general tone all-over. This will emphasize the dark greens of the big wave.

ADDING FOAM SHADOWS

Next comes the shadow construction of the foam (Plate LXX). Use still another fresh brush with a tone of cobalt blue, a touch of rose madder, and a suspicion of Naples yellow. Be careful not to make foam shadows purple. There must be a preponderance of blue tone, as the foam in shadow reflects the blue sky farthest away from the sunset. It has to be luminous because it is wet and reflective of light. Paint your foam shadows full strength; it is easier to put in the halftones of modeling afterwards by retouching, than to paint it light at first, working up to dark. Watch the big shadow masses. Practice and experience will teach you what to add for the smaller details. A little deeper tone of this color must be worked around the outer rocks to give the feeling of distance.

You now have all the picture massed in, except the highlights.

FINAL STAGES

The final stages (Plate LXXI) will be:

(1) The painting of the darkest portions of the rocks to develop their full character. For these, I used the half-dark brush after wiping it clean, and painted them with the same colors as my first lay-in, only full strength, but varying the tone with more raw sienna and less rose madder, according to the color change in the dark rocks.

(2) The top light influence of the sky on the rocks is shown in the completed picture by certain bluish tones. Being wet, they reflect the sky considerably. Cobalt blue and a touch of Naples yellow gave this.

(3) In order to give more character to the sunlit foam in the cove, where the tide causes it to rise to the surface in rounded masses, I used cobalt blue, viridian, and flake white where the pure water shows. This, carefully expressed, is the contrasting note to the contours of the foam pattern.

(4) The last painting was put into the light on the foam, and into the highlights on the rocks. The latter flashed like amber drops and were more brilliant than the foam. These flashes were Naples yellow and flake white, while the foam was rose madder, yellow ochre, and flake white. As Naples yellow is more brilliant than yellow ochre, the difference between the foam and the glitter was maintained. The rock surfaces being fairly square cut in character, the highlights were painted in quick, square touches.

A little green of the deep sea was worked into the lighter outer rocks to give the bloom of the wet parts. This is very noticeable when wet rocks at the sea edge reflect the light from the foam.

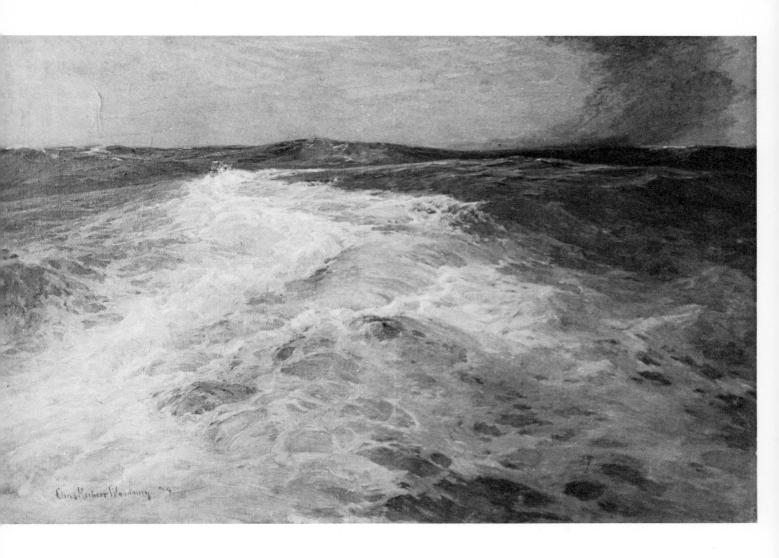

MID-OCEAN by Charles Herbert Woodbury. This extremely subtle open sea painting is the product of very close observation of the patterns of foam. The artist has not resorted to any of the more usual solutions, like a pattern of dark and light waves, or one large dominant wave, to develop his composition. On the contrary, he has depended upon an intricate, subtle pattern of foam to guide the viewer's eye very gently to the focal point of the picture. The viewer is almost unaware of the way in which the foreground foam leads his attention in a zigzag course from the dark patch at the very bottom of the canvas diagonally upward to the left, then diagonally upward to the right over the surface of a rolling wave, then left again along the margin of the foam, and finally to the one low wave which breaks the horizon. The zigzag movement is picked up again as the eye swings diagonally to the right and up along the curling patch of dark cloud, which curves around to the left again and brings the viewer around to the focal point of the composition. The extreme delicacy of the foam is worth studying and the reader should make many drawings of foam patterns to arrive at the knowledge necessary to create such a painting. *(Courtesy, Berkshire Athenaeum, Pittsfield, Massachusetts)*

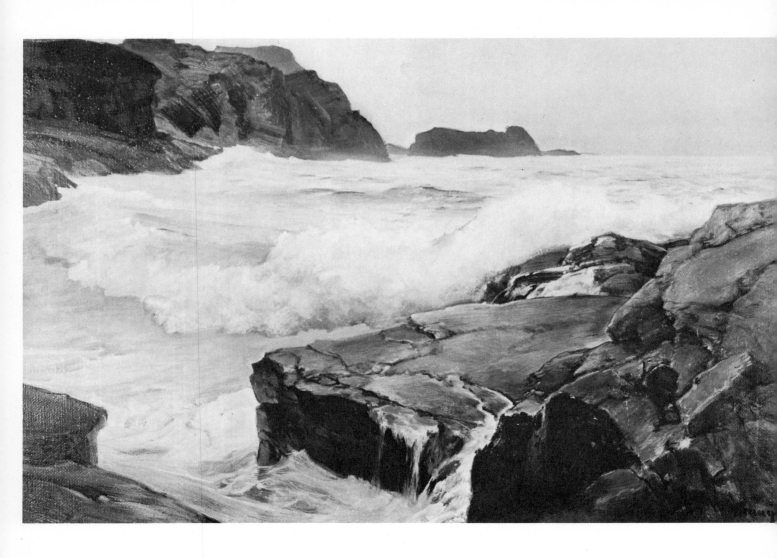

PASSING MIST by Frederick J. Waugh, 20″ x 30″. In painting rocks, it is important to remember that they are essentially geometric forms, with tops and sides that become planes of light and shadow. The rocks in the lower right have been visualized in just this way, the tops receiving the light and the sides falling into shadow. The shadows often pick up touches of reflected light from the sea beneath, as in the left hand edge of the central rock form, where the shadow is not uniformly dark, but has a delicate translucency. The shining surfaces of wet rocks, in particular, are likely to absorb and throw back reflected light. This painting is also an interesting example of atmospheric perspective. The foreground rocks are precise in detail, sharply defined, with strong contrasts of light and dark. The more distant rocks on the horizon have less detail, are painted more broadly, tend to be seen in silhouette, and grow progressively flatter and grayer as they recede from view. The path of the viewer's eye enters the picture at the bottom edge, travels between the rocks, and follows the sinuous curve of the breaking wave into the distance. (*Edwin A. Ulrich Collection, "Wave Crest" on-the-Hudson, Hyde Park, New York*)

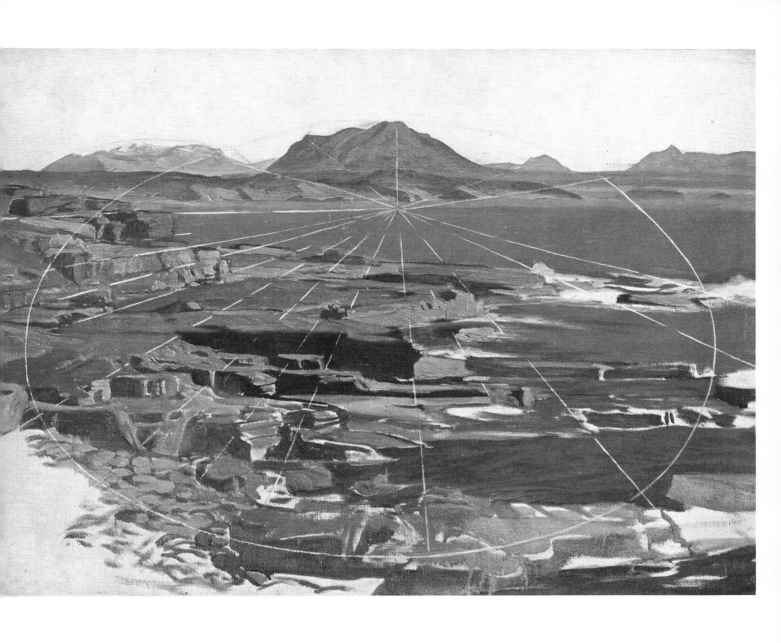

Plate I. The Quinag from Handa Island, Sutherland. *Center of interest should lie inside ellipse or circle. Here ellipse encloses items of interest. Lines of composition of rock forms fall into definite planes of recession and lead eye to focusing point of picture. White dotted lines pass through main points.*

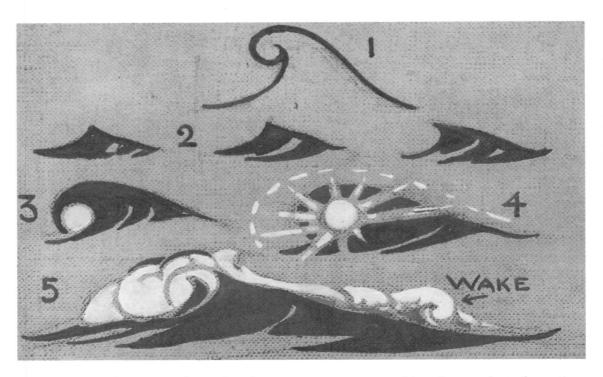

Plate II. *Analysis of in-shore wave movement and its effect on foam formation. Greek wave pattern (1). Wave moves toward shore (2). Wave falls over as it reaches shallow water (3). Wave top breaks into foam (4). Wake is left behind as forward movement continues (5).*

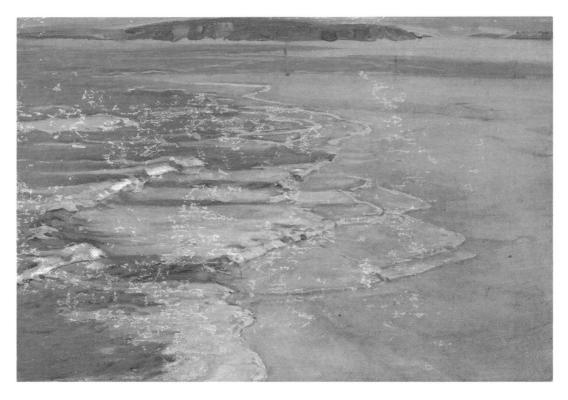

Plate III. Hayle Bar, St. Ives. *Perspective of breakers and their wakes emphasizes forward movement of breakers on flat beach.*

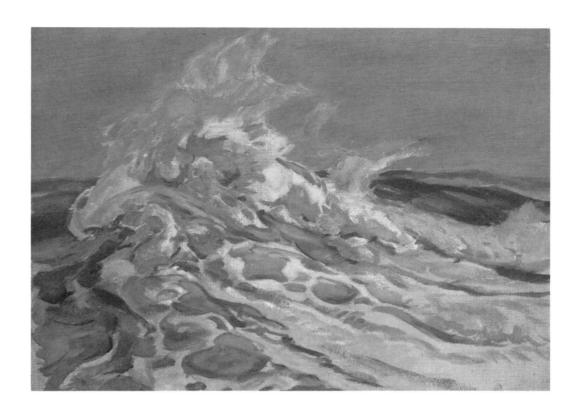

Plate IV. *Opposing forces in tidal movement. Receding wave rebounds and meets oncoming one. Like two waves breaking in opposite directions, rush-back meets oncoming breaker, top of which is forced up in mass of broken water and foam. Individuality of movement of each mass is retained.*

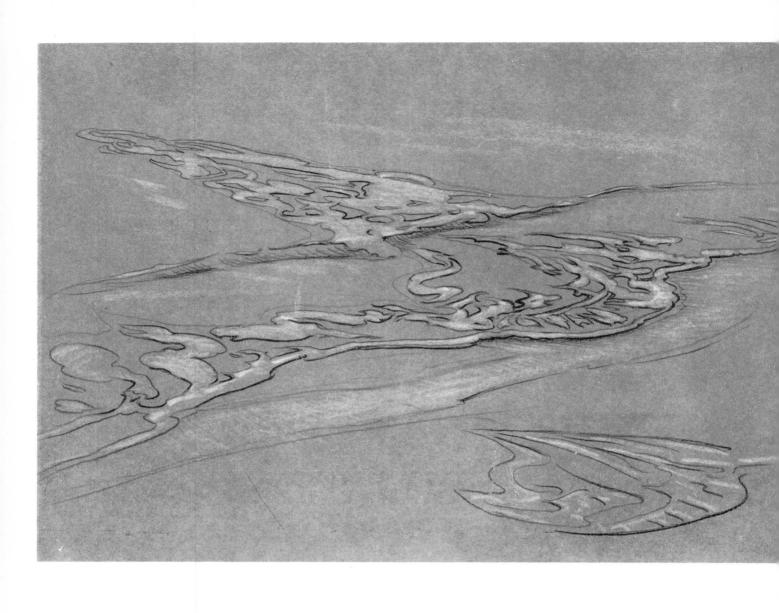

Plate V. *Study of foam pattern (1) shows forward movement of shallow waves breaking on flat beach, sketched from cliff edge with chalk on brown paper. Creeping pattern suggests lacework. Small sketch in lower right corner is first rough outline of main pattern.*

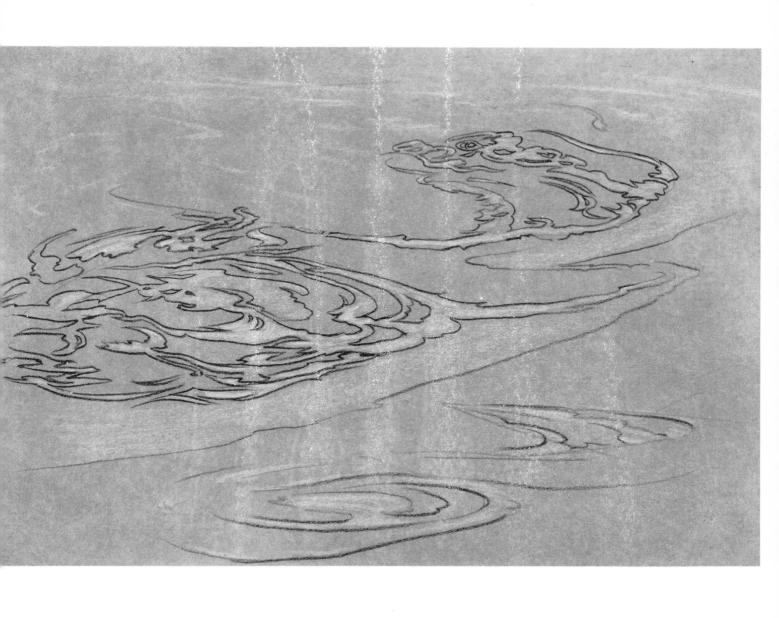

Plate VI. *Study of foam pattern (2) shows end of movement. Larger mass of foam is quietly swirling in slight depression of sand before dispersing. Lacework pattern remains, but force of wave is exhausted. Two small notes at bottom show how main lines were blocked in first.*

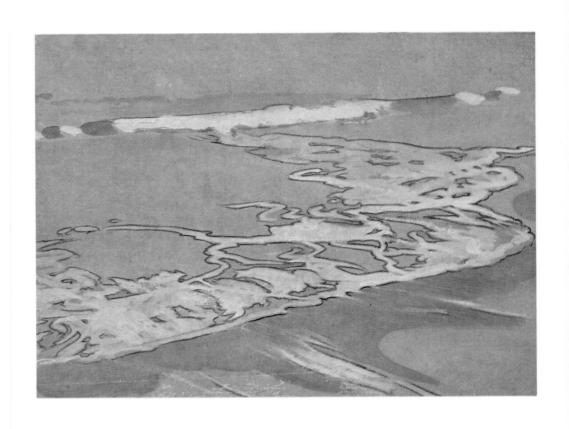

Plate VII. *Study of foam pattern (3) shows added strength in forward movement of foam from heavier breaker. There is more volume because flow-in is deeper. Note design of pattern again, with definite lines of movement.*

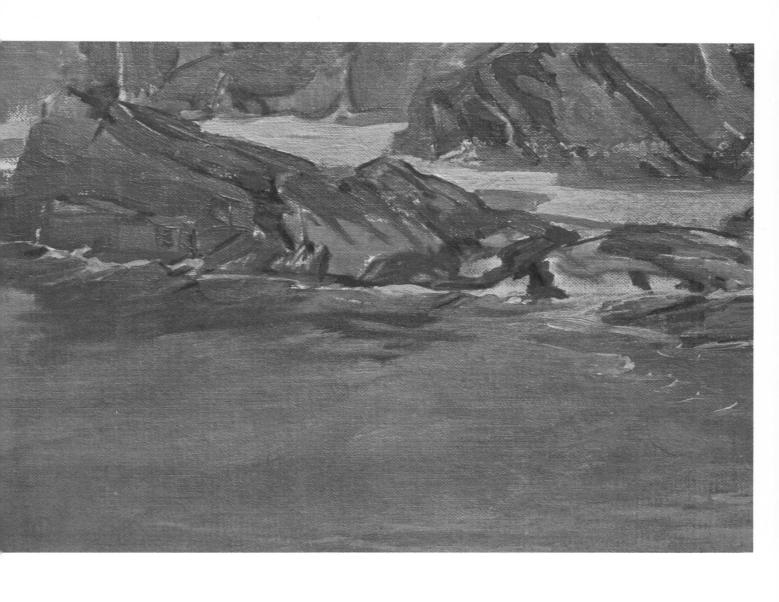

Plate VIII. Sunset Glow, Kyle of Tongue, Sutherland. *Example of extreme simplicity of color choice. Sketch was painted in only three colors: cobalt blue, rose madder, Naples yellow. Fairly dark toned subject was chosen to emphasize possibilities of power of combined colors. No white was used. Naples yellow alone was sufficient to reduce color density where necessary.*

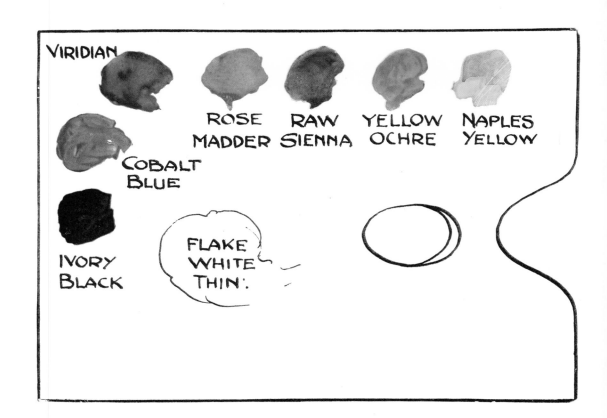

VIRIDIAN

ROSE
MADDER

RAW
SIENNA

YELLOW
OCHRE

NAPLES
YELLOW

COBALT
BLUE

IVORY
BLACK

FLAKE
WHITE
THIN'.

Plate IX. *Palette discipline and graduated color strength. Make a ritual of your color sequence on palette: lightest hue on right, graduating through to black. Keep to this order.*

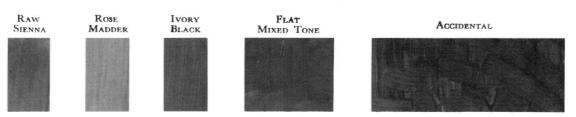

| RAW SIENNA | ROSE MADDER | IVORY BLACK | FLAT MIXED TONE | ACCIDENTAL |

No. 1. *Lay-in tone for rocks and cliffs, no flake white added.*

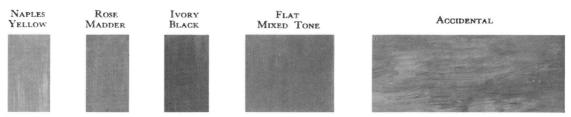

| NAPLES YELLOW | ROSE MADDER | IVORY BLACK | FLAT MIXED TONE | ACCIDENTAL |

No. 2. *Preliminary for sand and similar subjects, mixed with a little flake white.*

| NAPLES YELLOW | ROSE MADDER | COBALT BLUE | FLAT MIXED TONE | ACCIDENTAL |

No. 3. *First tone for foam or certain cloud shadows, mixed with a little flake white.*

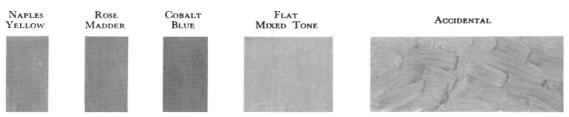

| NAPLES YELLOW | ROSE MADDER | VIRIDIAN | COBALT BLUE | FLAT MIXED | ACCIDENTAL |

No. 4. *Preliminary tints for shadows and certain sky effects in moonlight, mixed with a little flake white.*

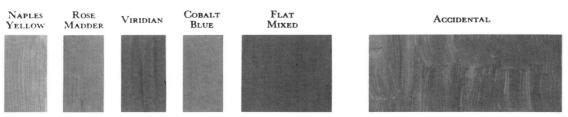

| ROSE MADDER | VIRIDIAN | COBALT BLUE | FLAT MIXED | ACCIDENTAL |

No. 5. *First tones for brilliant deep sea effects, no flake white added.*

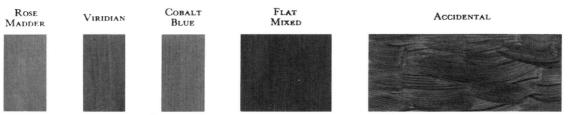

Plate X. *Chart of more important tints in this book. Keep your color "accidental," rather than mixed flat, to insure purity, luminosity, and vibration of tone.*

Plate XI. *Analysis of brush touches in wave and foam movement. Watch the makeup of the wave and try to copy the direction of its movement in your brushstrokes.*

Plate XII. *Direction of strokes in technique of painting heavy spray. Pattern of foam reflects cause and effect. Curved side of rock forces wave to rebound seaward into wind in arc of almost solid water, while gale blows water into flying sheets of spray.*

Plate XIII. *Study of a rock. Rocks all have modeling, facets like a precious stone. Brush should follow direction of these surfaces, giving strong sense of construction.*

Plate XIV. *Diagrammatic sketch of rock forms shows how direction of touches of color contributes to solidity and sense of natural growth.*

Plate XV. *Clouds over sea are done in same manner as foam, adapting touches to particular form. Sky is flatter than clouds to give effect of distance.*

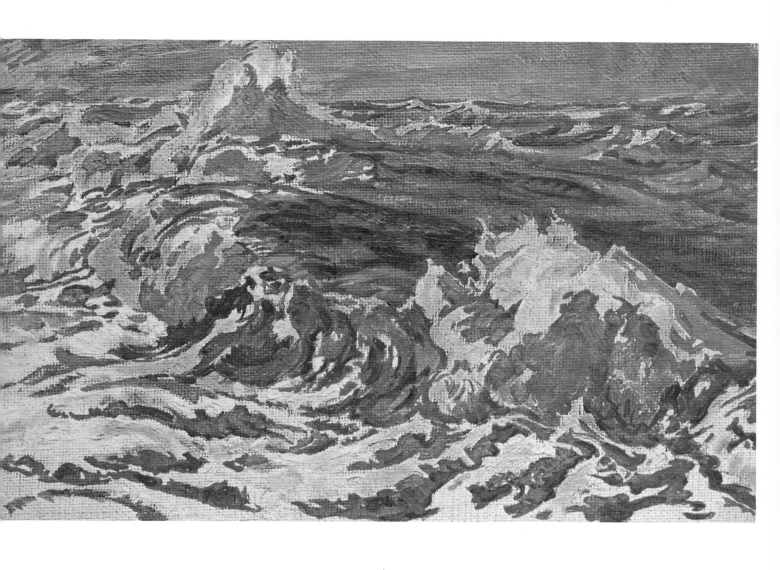

Plate XVI. Morning After the Gale, Land's End. *Touches of thick paint contribute to expression of movement of elements. Color was so thick that it was almost modeled to forms. This was study for large painting, 6' x 4', executed at top speed, with paint applied directly and left "unteased." Later retouching was avoided to prevent deadening freshness of color.*

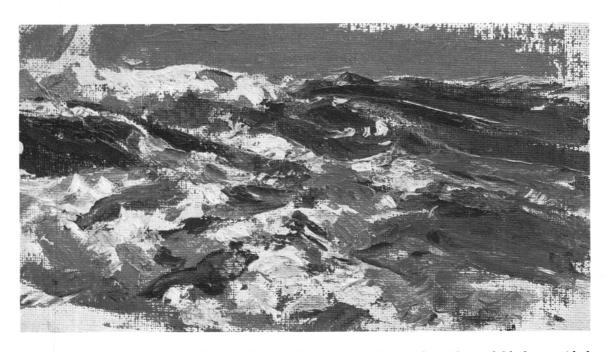

Plate XVII. *Palette knife sketch was painted entirely with steel blade, unaided by brushes. This method obtains much purity of color, but can be used by only most capable painters.*

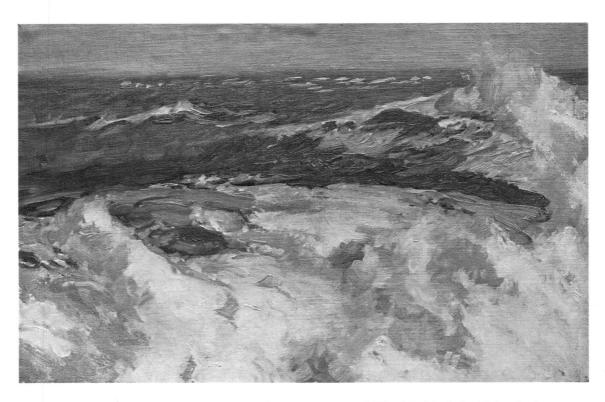

Plate XVIII. *Thumb and finger painting of* Wind Behind the Tide, St. Ives, *uses unorthodox technique to soften paint that renders flying spray.*

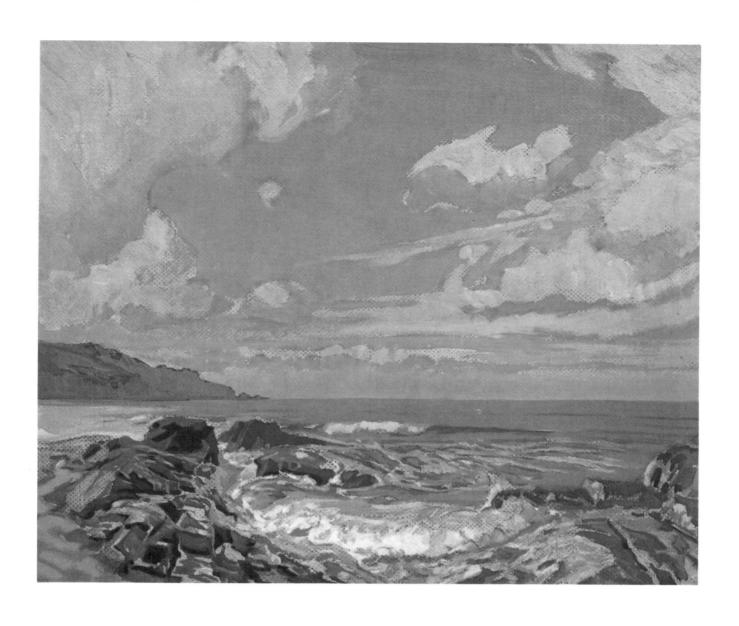

Plate XIX. Morning at Hor Point, St. Ives. *Rocks and lines of foreground sea lead eye to middle of picture. Clouds travel around ellipse and convey sense of movement. Horizon provides restful line, carefully placed one third (not half way) up.*

Plate XX. *Study in colored chalk of tidal movement for left of completed picture, with particular attention to overflow of sea pools after flooding by breaking wave. Touches of colored chalk are added as memory aid.*

Plate XXI. *Study in colored chalk for right of completed picture caught character of movement and line of composition before tide rose too high.*

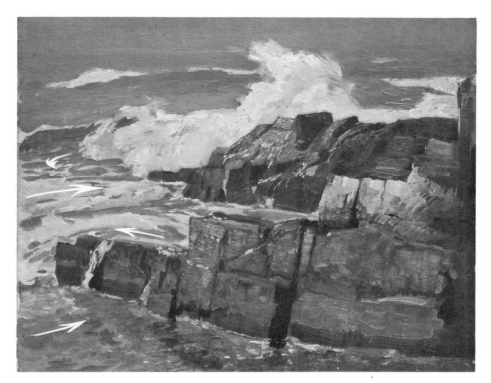

Plate XXII. Rocks at Wicca Cove, St. Ives. *To prevent bold outlines of rock forms from leading eye out of scene to left, highlight of breaking waves occupies central portion at top of main rock form. Tidal movements lead eye to center.*

Plate XXIII. *Forward movement of foam is reinforced by directional brushstrokes, which enliven center of interest.*

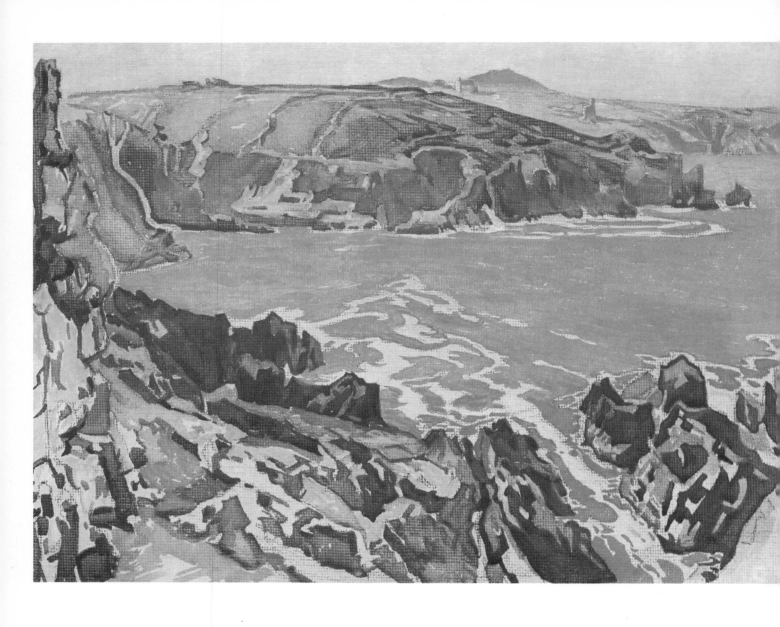

Plate XXIV. Porthglaze Cove, St. Ives. *Picture is purposely left unfinished to show building up of first color areas to show construction and lighting. Note highlights of interest in lines of foam being drawn out by tidal action from between rocks.*

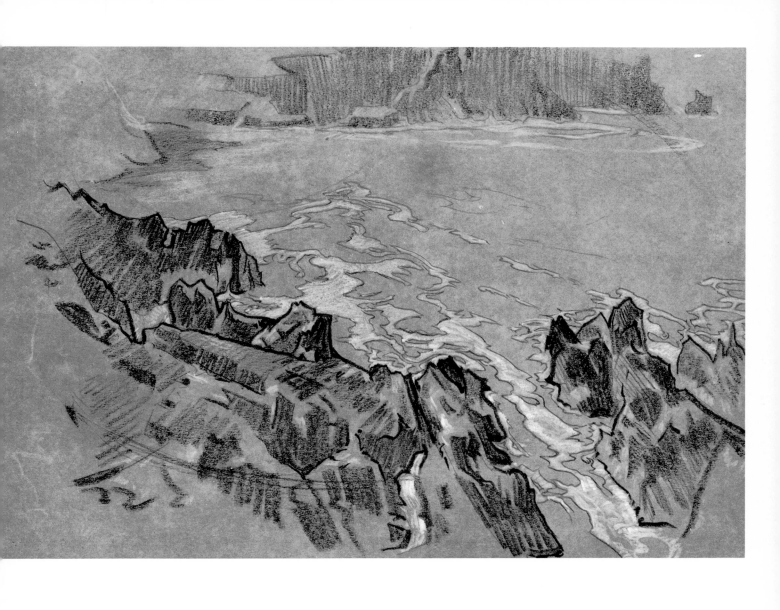

Plate XXV. *Study for* Porthglaze Cove, St. Ives, *focuses on keynote of composition, foam pattern leading to center of cliff forms.*

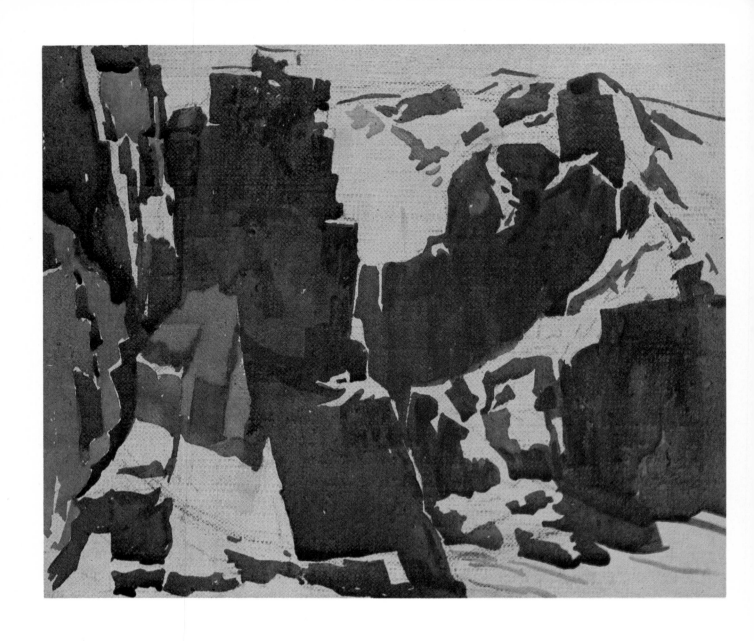

Plate XXVI. Zennor Cliffs, Cornwall *(stage 1)*. *Keynote of scene was emphasized by careful shadow construction from very beginning. Elliptical swinging curve of main rock forms and lines of rock pattern lead to center of composition.*

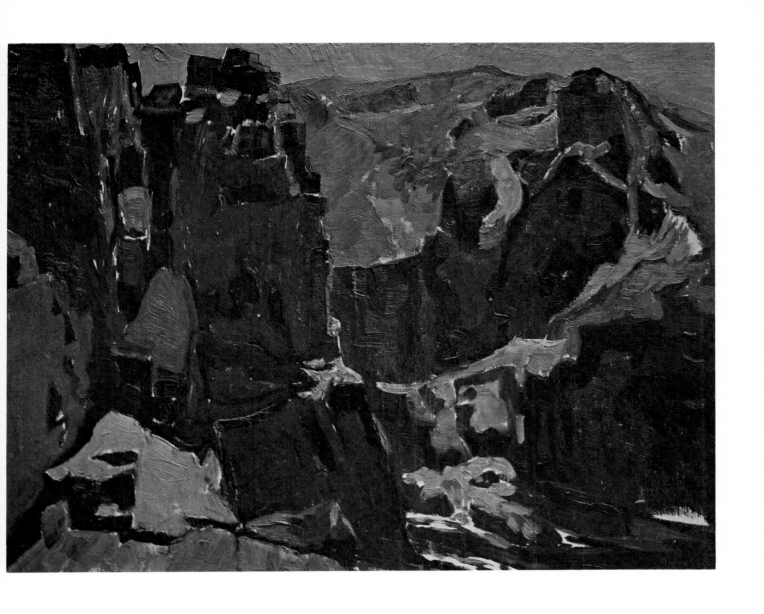

Plate XXVII. Zennor Cliffs, Cornwall *(stage 2).* *In hurry to lay in complete shadow construction and bulk of masses, some important rock shapes were over-painted and character was altered by clumsy painting.*

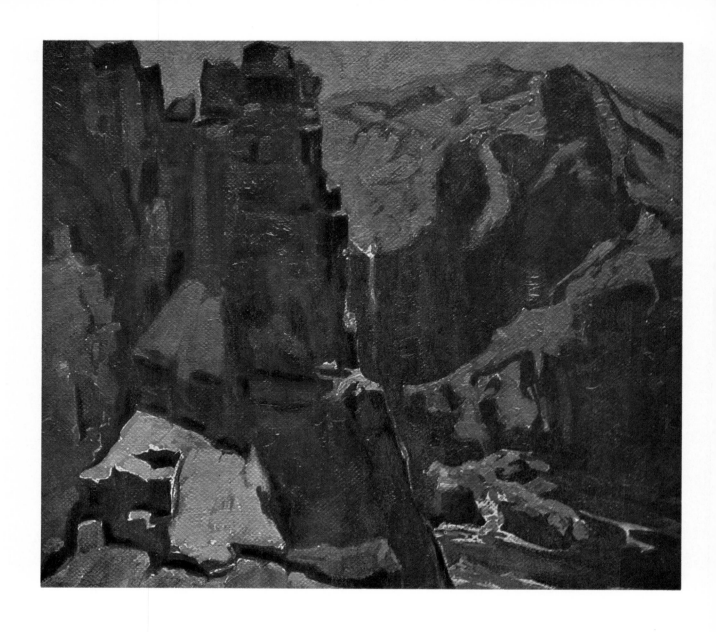

Plate XXVIII. Zennor Cliffs, Cornwall *(final 3)*. *Rock forms were finally reconstructed. Painting over color is always risky, as one is apt to lessen vitality of tone. Color was thickly painted to reassert vitality.*

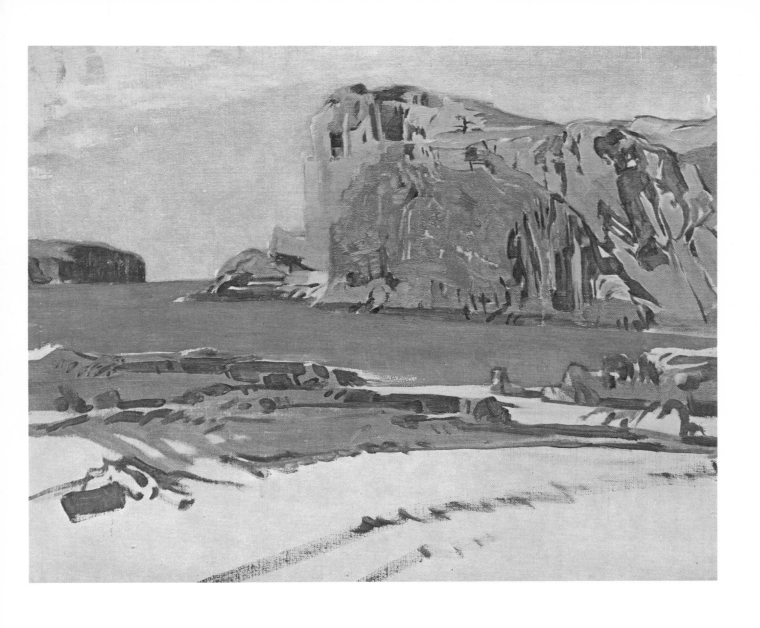

Plate XXIX. Neave Island, West Coast of Sutherland *was painted in one and a half hours. Though sketchy, all essentials of composition and shadow construction are there.*

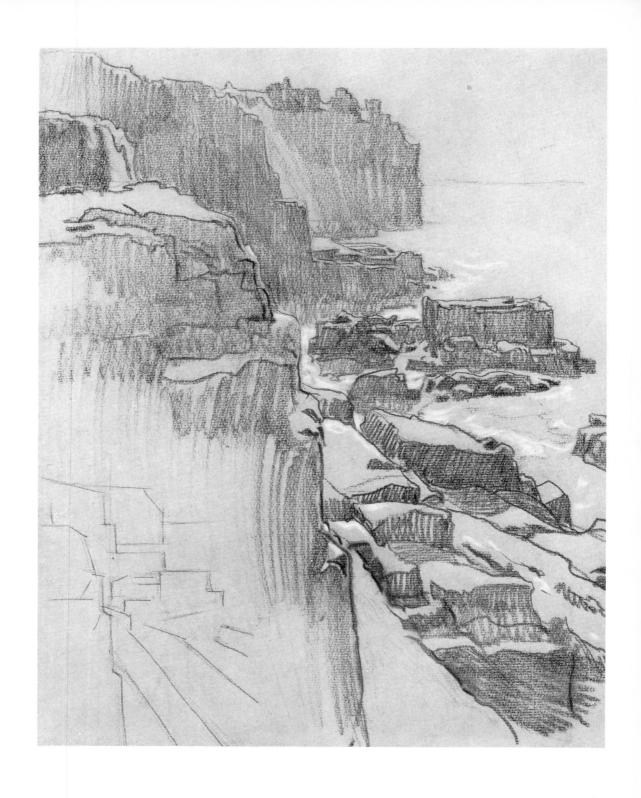

Plate XXX. Cliffs at Land's End. *Study in black and white chalk on toned paper shows constructional manner of building up quick sketch, emphasizing big masses of cliff outline. Note geometric diagram in lower left hand corner of drawing.*

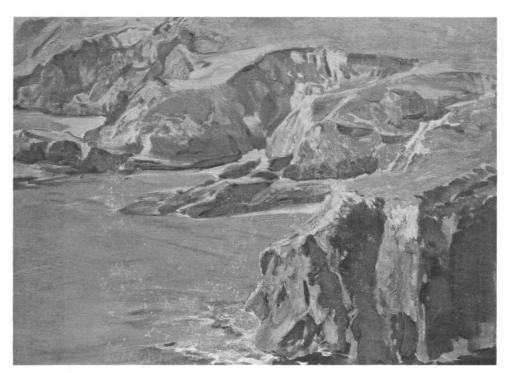

Plate XXXI. Autumn at Bolt Head, Salcombe, South Devon *(1). This first study of the subject was made at wrong time of day, early evening when equal all-over light failed to emphasize forms. Composition is repetitive and monotonous. Compare Plate XXXII.*

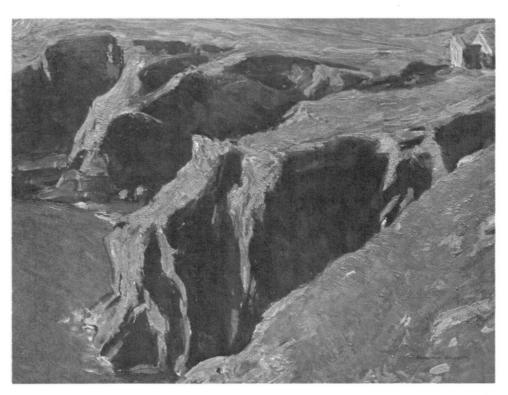

Plate XXXII. Autumn at Bolt Head, Salcombe, South Devon *(2). Second study concentrates on main cliff form, shows more dignity. Proper lighting conditions and glow of sunset produce more inspiring light and shade and deeper tone.*

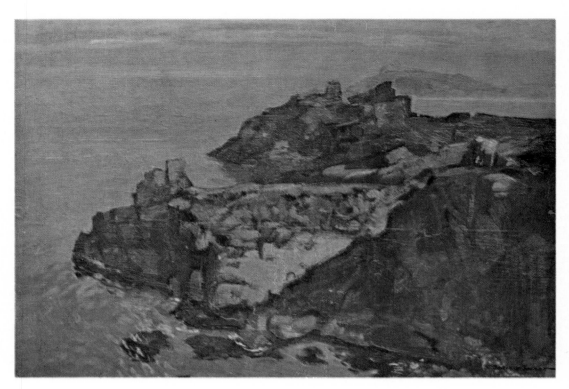

Plate XXXIII. Carrick Du, St. Ives. *Passing touch of sunlight emphasizes light on central portion of near cliff. Test importance of this part by covering it with your hand; scene becomes devoid of interest.*

Plate XXXIV. *Underwater rocks and tidal influence on their shapes. Shapes of underwater rocks are defined by movement of element above them: ripple of water feathers their edges in shape with tide. Rocks are painted with local color of cliffs at water's edge, but much darker.*

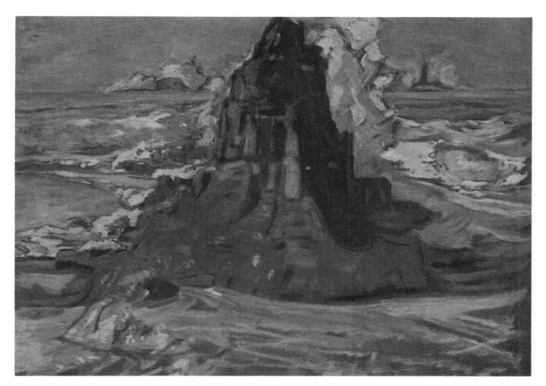

Plate XXXV. The Armed Knight, Land's End *(1)*. *This first study was carried out in difficult weather. Wave movement and glow of dawn are overstressed and detract from dignity of rock formation. Another attempt was indicated; compare with Plate XXXVII.*

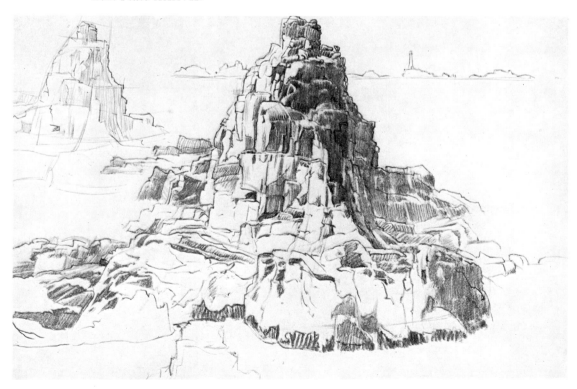

Plate XXXVI. *Drawing of* The Armed Knight, Land's End. *Careful chalk drawing on white paper, made under more sheltered conditions, resulted in better understanding of rock's individuality. Notice twist in upper part, construction note in top right hand corner.*

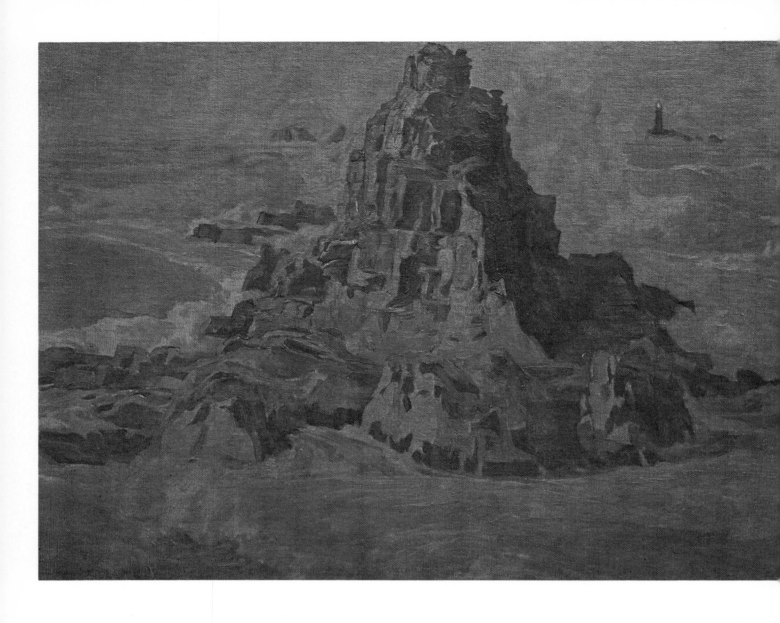

Plate XXXVII. The Armed Knight, Land's End (2). *In final picture, color scheme is lower in tone, rock retains dignity, sea forms are kept suggestive, but drawing is evident. In painting such subjects, do not let apex of rock take too central position, which cuts canvas in half; here heaviest part of rock is right of center.*

Plate XXXVIII. *Sketch diagram to test recession of tones. Note gradual recession in tone from highest light on wave no. 1 right through to no. 4. Foam takes on influence of sky and atmosphere as each wave breaks farther.*

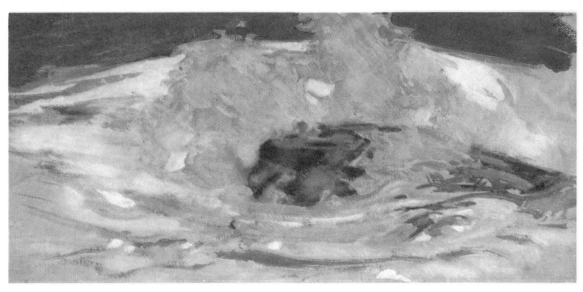

Plate XXXIX. *Difference in tone of cast up spray and foam in mass. When wave strikes rock, spray that is cast up in air is not as white as bulk of foam. Shattered spray has more shadow or color from influence of sky, rocks, shore.*

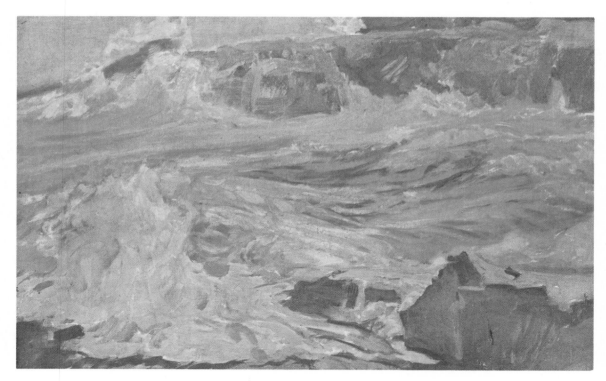

Plate XL. *Pale green sea provides complementary coloring to foam on gray day. Heavy masses of foam and water, pale green in tone, provide complementary color in rose gray of thick spray.*

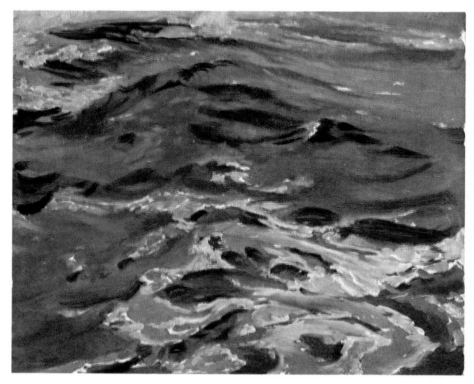

Plate XLI. *Study from cliff edge. Foam is pinky gray color, induced by green complementary in sea. Sandy bottom reflects influencing light, conveys transparency and depth to water. Black portions suggest submerged rocks.*

Plate XLII. Heavy Seas Breaking at Land's End *(1)*. *First study did not have enough foreground interest to support big masses of foam at back, needed some strong line of composition to fill empty ground.*

Plate XLIII. *Recoil movement of succeeding waves, rebounding from some fore-ground rocks, took shape of small or great curves, according to force, and moved outward in ever widening circles. This suggested solution to problem of fore-ground interest in Plate XLII.*

Plate XLIV. Heavy Seas Breaking at Land's End (2). *Preliminary construction of second study (compare with Plate XLII) shows added foreground interest based on study in Plate XLIII. Note great path which has been created between main lines, sloping up to open sea.*

Plate XLV. *Quick open sea sketch (stage 1). In first lay-in, semi-dark wave forms were painted first to emphasize pattern correctly. Highlight is foam-capped wave in middle; from this point, movement passes along curve of swell, returns through heaving line up to left.*

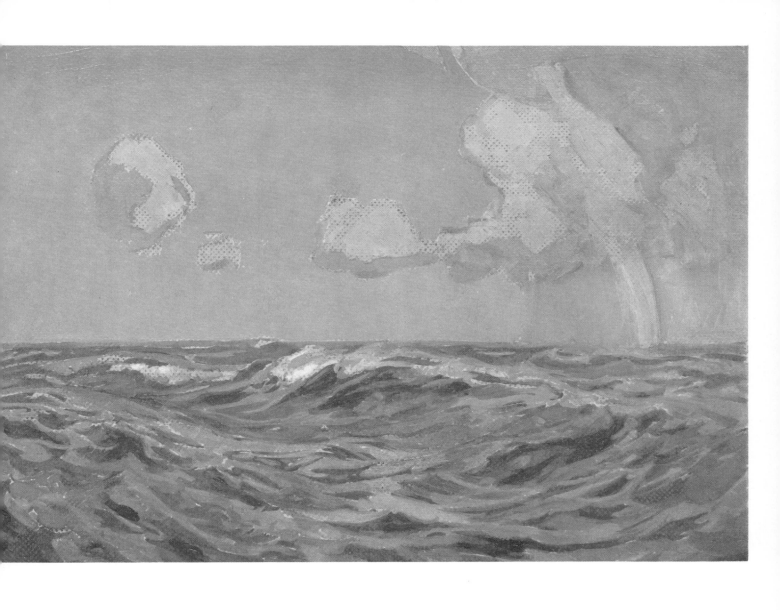

Plate XLVI. *Quick open sea sketch (final stage). Cobalt and viridian formed basis of wave forms, followed by lighter passages to blend with and eliminate hard edges. Into this, and into some bigger dark masses, were touched reflections of open sky and cloud color. Note touches of top lighting on sea. Sky was last.*

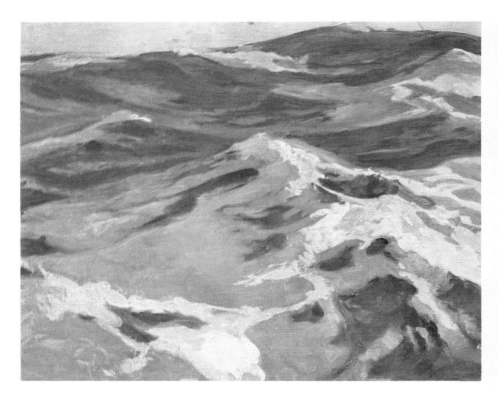

Plate XLVII. Evening, Prawle Race, South Devon, *was painted in few colors: Naples yellow, viridian, ivory black, touch of rose madder, flake white. Simple palette helps when painting quickly from deck of ship.*

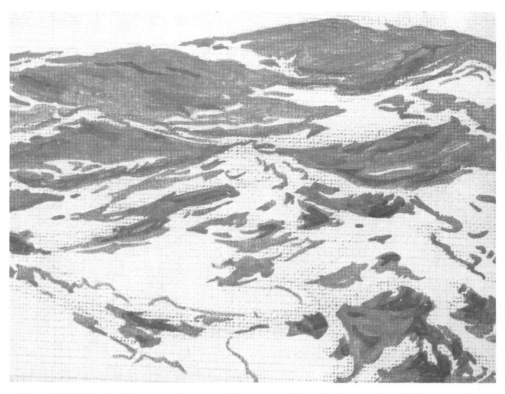

Plate XLVIII. *Preliminary lay-in of* Evening, Prawle Race, South Devon, *shows general pattern and lines of movement; defines essentials of weight, construction of foam pattern, spacing of masses to help perspective of water.*

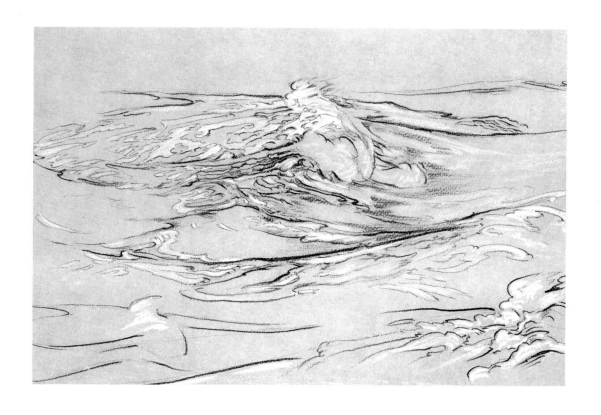

Plate XLIX. *Main lines of wave movement and foam pattern. This note on tinted paper was done at same time as painting in Plate XLVII.*

Plate L. Bow Wash of the Liner Otranto in the Bay of Biscay with Rainbow Effect. *Painted from heaving deck of liner, movement of wash from vessel's bow, with windblown spray forming rainbow, provided fascinating subject. Coastal trips on shipboard are great help to sea painter, providing view of element from fresh angle.*

STACK

Plate LI. *Memory aids, features of cliff scenery, Handa Island, Sutherland, were sketched in pencil from passing motorboat. Such notes help quicken memory at later period if background is required for sea picture.*

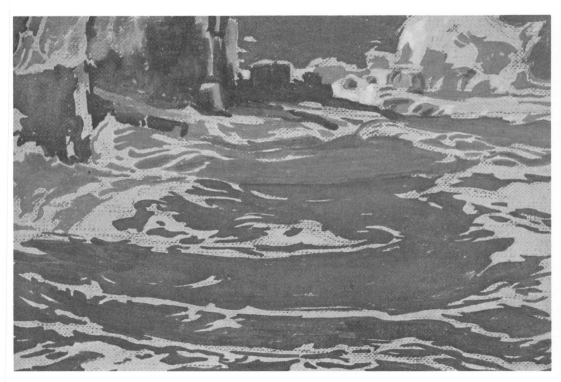

Plate LII. The Armed Knight, Land's End *(stage 1). Success of this stage lies in careful observation of size and shape of foam pattern. Big planes of sea in middle were painted first, leaving lateral lines blank, gradually working around foam pattern with viridian, touch of Naples yellow, ivory black, cobalt blue, little flake white, plus touch of rose madder in rock forms.*

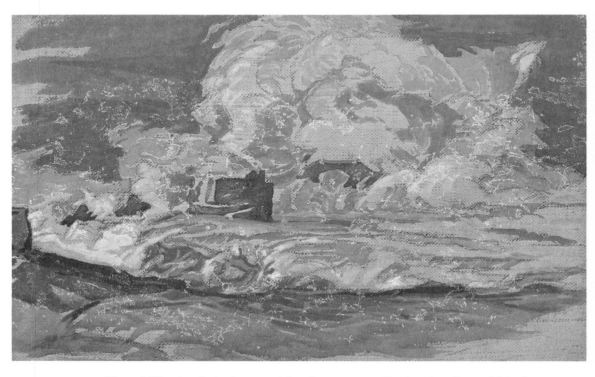

Plate LIII. *Analytical note of big foam mass. Explosive effect of big foam mass was painted separately for reference, giving idea of action and touches of paint necessary in final picture (Plate LIV).*

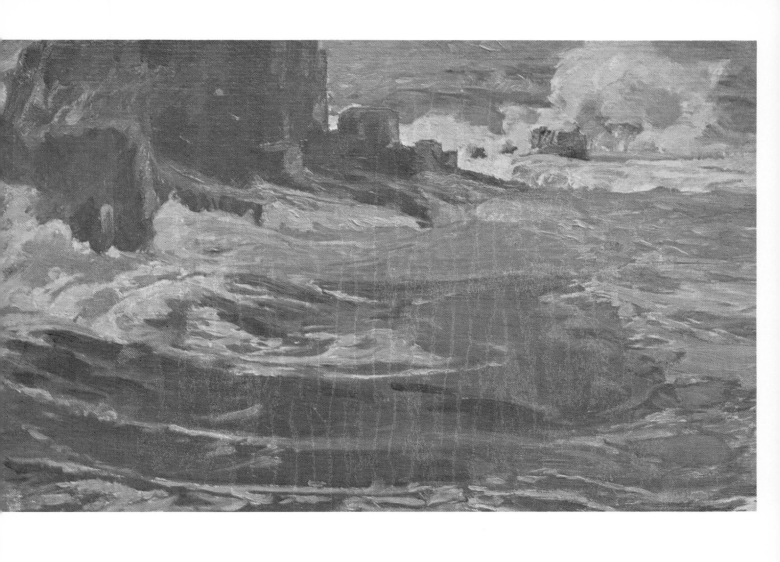

Plate LIV. The Armed Knight, Land's End *(final stage) reveals four distinct planes of sea: (1) great foreground mass of water, quiet in tone, half lit through passing cloud; (2) bluish shadow of rock on sea; (3) dark gray-green which forces up tone (4) on sea and foam in strong side light at top.*

Plate LV. *First study in black and white chalk of ground sea at Clodgy, St. Ives, showing forward movement and rebound. Note forward movement in big wave at right; rebounds from end rock at back and foreground reef; motion in big wave, caused by long curve of outline.*

Plate LVI. *Second study in black and white chalk of backwash, showing main lines of movement. Note effect of backwash pouring seawards from lower rock forms. In constructional sketch in lower right hand corner, arrows pointing left show opposing movements of rush-back and gathering force of rising tide in arrows pointing right.*

Plate LVII. *Analytical study of backwash and influence of submerged rock forms. This important element required separate study as memory aid.*

Plate LVIII. Ground Sea at Clodgy, St. Ives *(1)*. *Third record was painted in following color sequence: (1) dark toned sea painted first, with light parts left pure canvas, in cobalt blue, rose madder, viridian, no white; (2) green pattern in water painted in viridian, cobalt blue, some white; (3) foam shadows in cobalt blue, touch of rose madder, Naples yellow, some flake white; (4) sunlight on foam in Naples yellow, touch of rose madder, flake white.*

Plate LIX. Ground Sea at Clodgy, St. Ives (2). *Final painting gathers all previous incidents into harmonious composition (see Plates LV, LVI, LVII, LVIII). Preliminary lay-in of composition is shown, emphasizing movement and pattern of sea and foam, with foam shapes clearly defined to avoid indefinite or "faked up" effects later.*

Plate LX. Porthmeor Beach, St. Ives *(1)*. *In this low tide scene with clear sky, horizon line is one quarter down from top; sand pools and tidal markings animate foreground, creating feeling of space.*

Plate LXI. Porthmeor Beach, St. Ives (2) *drops horizon two thirds down from top. Sky is animated by clouds; breakers are nearer for composition; they add character and support sky space. Brushstrokes respond to receding planes of beach and domed sky.*

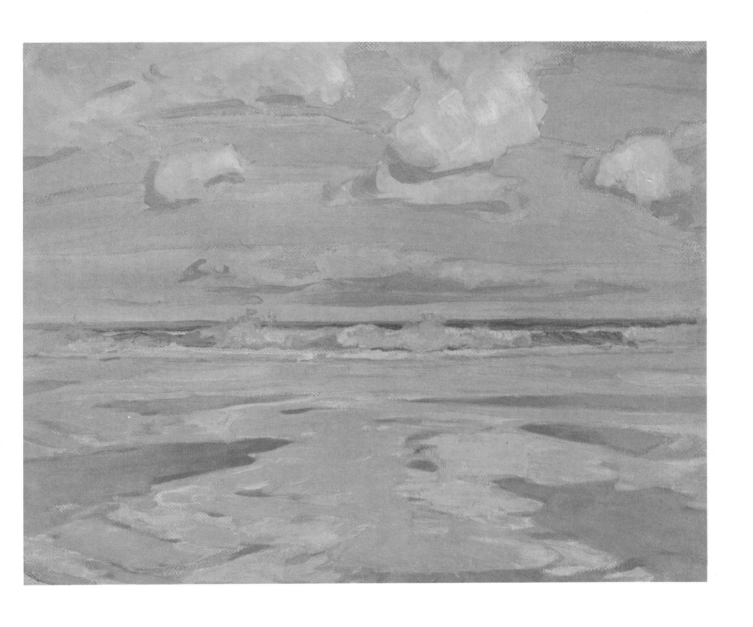

Plate LXII. Evening *shows balanced areas of sky and beach. Beach is very flat; pools reflect clouds. Sea pools are darker than sky, preventing distraction of too many "highlights" in sky and shore.*

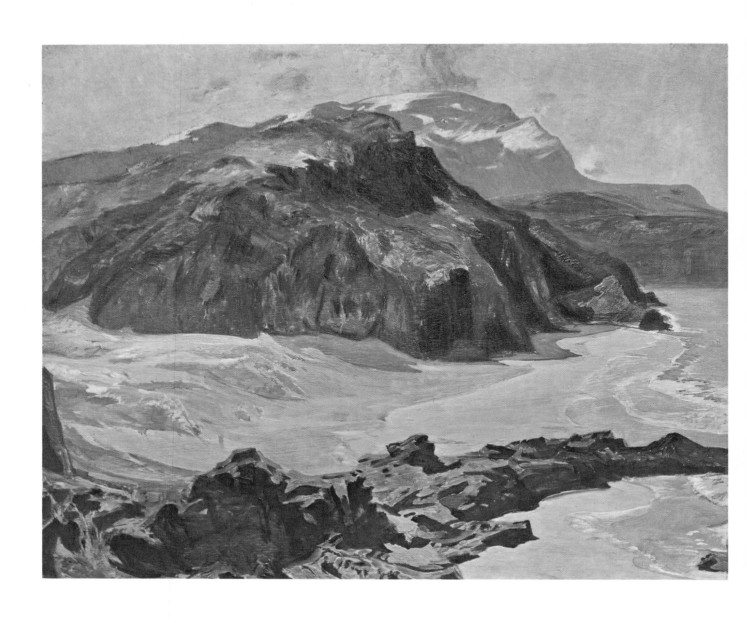

Plate LXIII. Ben Hope and the Kyle of Tongue, Sutherland. *Beach scene is shown in perspective with landscape background. Do not select too complicated a view. Look for important lines of rhythm and construction. "Accidental" handling of color makes rock mass solid in structure.*

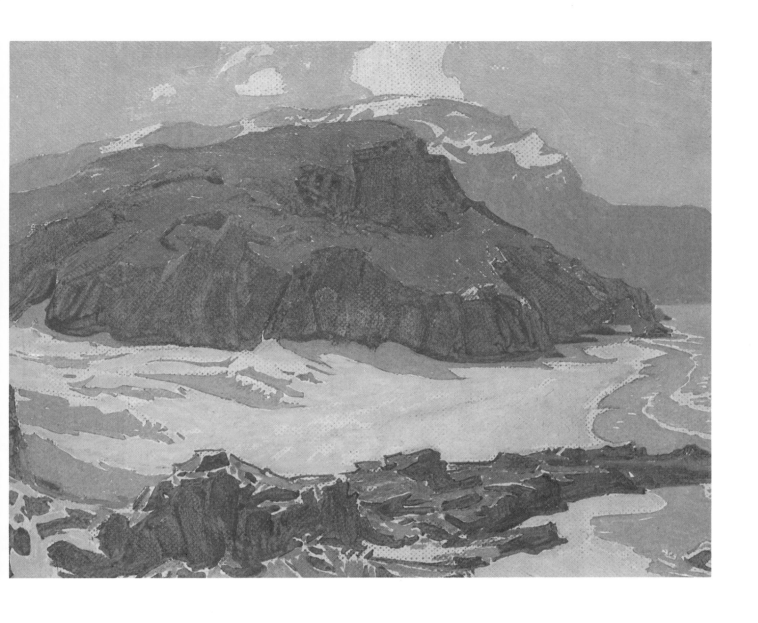

Plate LXIV. *Preliminary painting*, Ben Hope and the Kyle of Tongue, Sutherland. *Note complementary color of sky and sand, constructional technique of cliffs and rocks. Eye centers on sandy beach; great care was put into drawing around foam outlines in colbalt blue.*

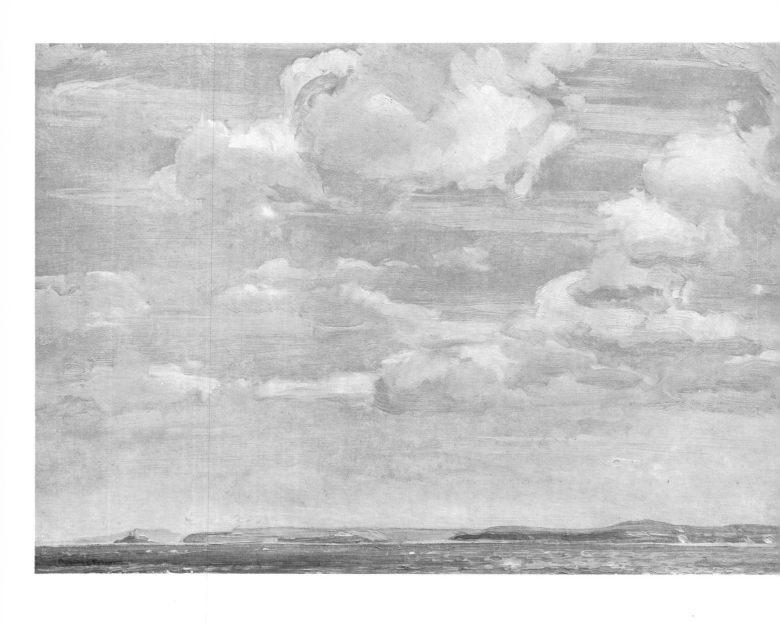

Plate LXV. Summer Morning, St. Ives Bay. *Doming of sky and carefully pat-
terned clouds contribute to aerial perspective. Clouds are pearly in tone, full of
light, showing quiet, restful effect of early summer morning. Low horizon adds
spaciousness to sky and note of sea color is useful contrast.*

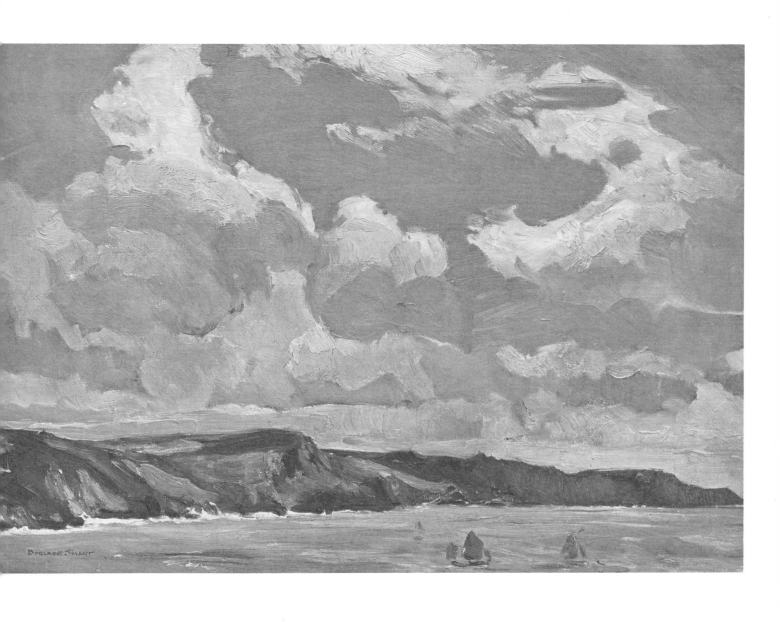

Plate LXVI. Prawle Point, Salcombe, South Devon. *Boisterous weather—stiff breeze and thundershowers—is reflected in lively technique of color touches. Do not forget to paint sky color after shadow portions of clouds, leaving patches of bare canvas proper shape for light parts of clouds.*

Plate LXVII. *Demonstration (stage 1). All half-dark portions of rocks are blocked in with raw sienna, rose madder, and ivory black, with an occasional touch of linseed oil for transparency and fluidity. Follow shadow outlines with precision and visualize composition completely at this stage.*

Plate LXVIII. *Demonstration (stage 2). Lighter portions of rocks are painted in raw sienna, rose madder, Naples yellow. Lights are pure canvas where wet parts catch glitter of light. Much of original hardness (stage 1) disappears as you come into contact with edges of preliminary lay-in.*

Plate LXIX. *Demonstration (stage 3). Half-dark portions of sea are painted with viridian, rose madder, Naples yellow, emphasizing line of motion of dark greens of big wave.*

Plate LXX. *Demonstration (stage 4). Shadow construction of foam is painted with cobalt blue, touch of rose madder, suspicion of Naples yellow. Be careful not to make foam shadows purple, but blue, as foam in shadow reflects sky farthest away from sunset. Paint foam shadows full strength.*

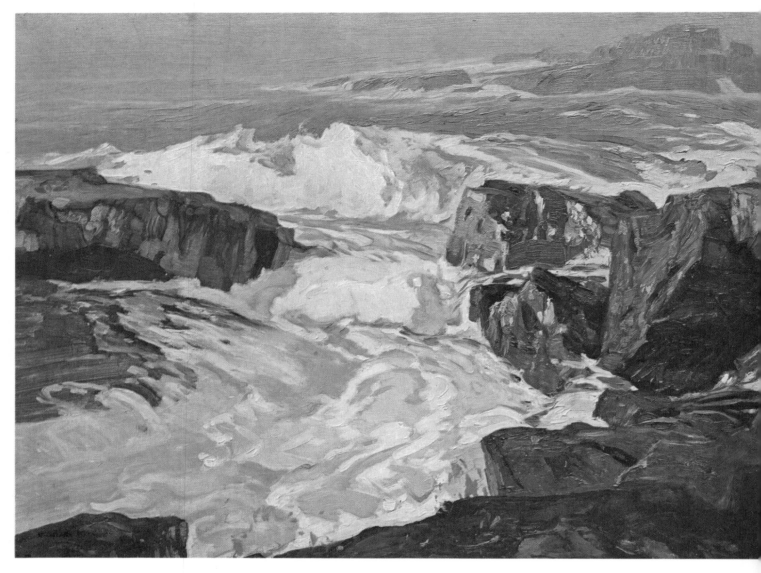

Plate LXXI. Sunset Glow at Clodgy, St. Ives (*final stage of demonstration*). *Darkest portions of rocks were painted same colors as first lay-in to develop full character. Top light influence of sky on rocks was indicated in cobalt blue, touch of Naples yellow. Pure water was painted with cobalt blue, viridian, flake white to give more character to sunlit foam. Final notes were light on foam (rose madder, yellow ochre, flake white), highlights on rocks (Naples yellow, flake white). A little sea green was worked into outer rocks to give bloom of wet parts.*

Plate LXXII. *Study in colored chalk of foreshortening in wave movement. Do plenty of sketches of waves breaking or moving directly toward you to study problems of foreshortening. (upper right)*

Plate LXXIII. August Moonrise, St. Ives Bay. *Here is color in fullest sense, but muted in tone. Sea near far shore is ruddy in color, while path of light, as it approaches foreground, is of golden quality. More emphatic contrasts of light and shade and color are in path of reflected light. Sea spaces to left and right are quieter in tone and form, adding space. (lower right)*

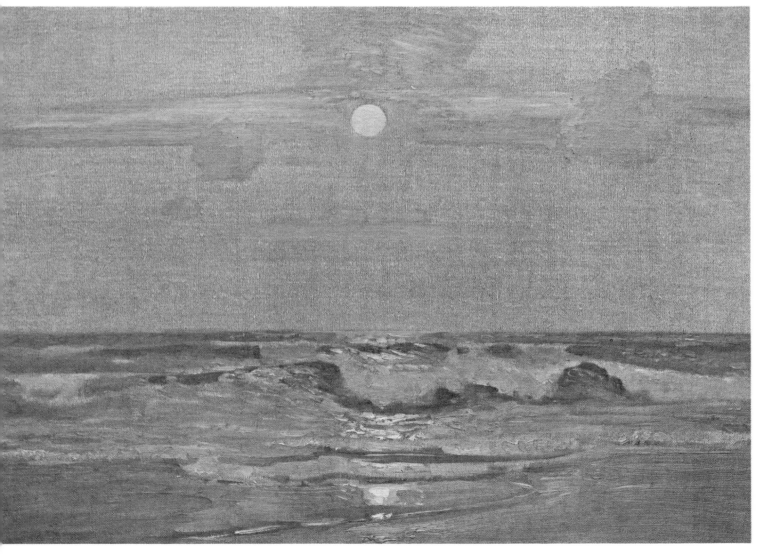

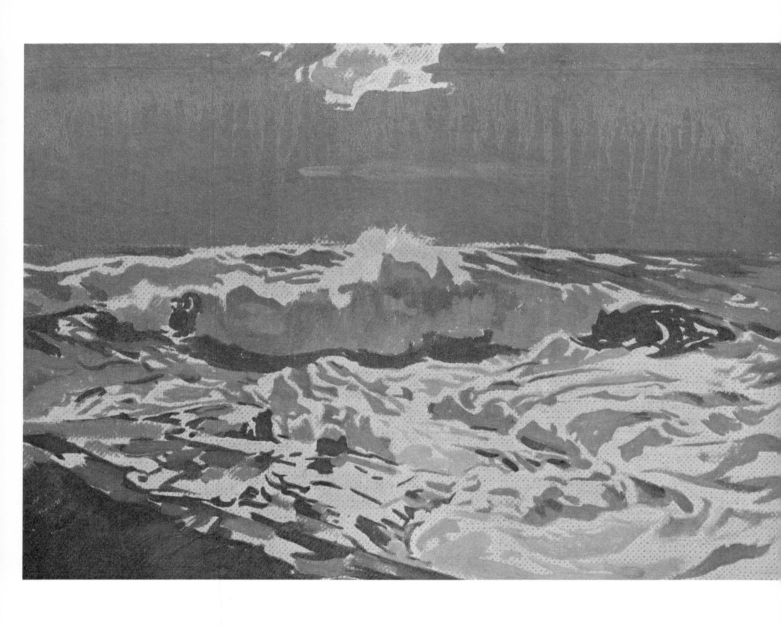

Plate LXXIV. Moonlight, St. Ives (*stage 1*). *First color tones were painted with Naples yellow, viridian, touch of rose madder, ivory black, a little flake white. Moonlight shadows must be luminous, dense, but not black!*

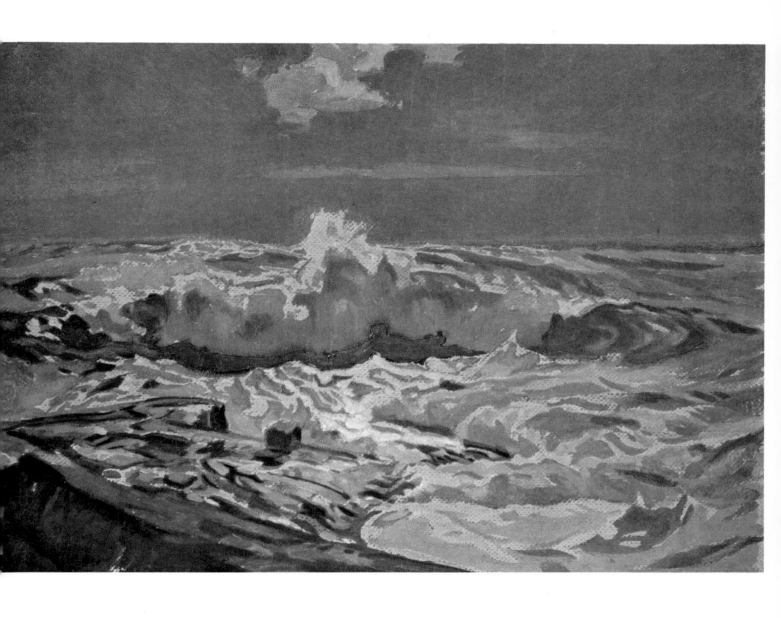

Plate LXXV. Moonlight, St. Ives *(final stage). Same colors were used in intensi-fied tones, with rose madder and Naples yellow for golden touches. Moon is not shown, but cloud creates illusion, leads eye to center of wave interest. As waves recede, they become smaller, less reflective; crescendo of light increases as it ap-proaches foreground.*

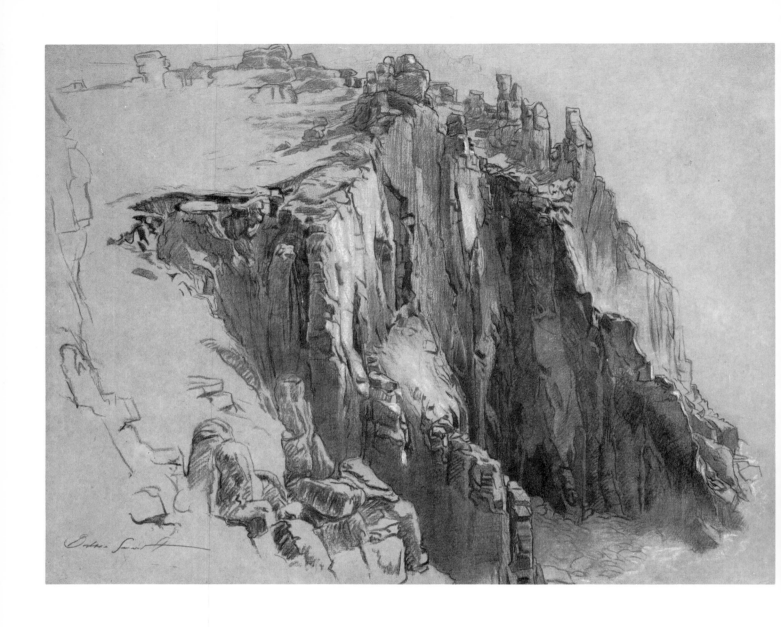

Plate LXXVI. *Preliminary study in black and white chalk of Cathedral Rocks, Land's End, defined character of cliff, tested viewpoint as suitable for final painting. Empty ground, lack of foreground support were solved by introduction of rocks at foot of slope.*

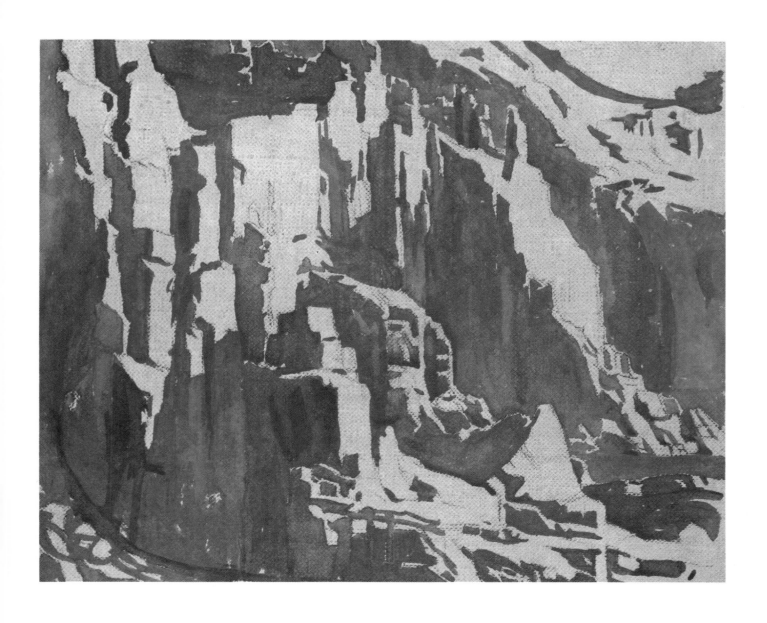

Plate LXXVII. Moonlight, Cathedral Rocks, Land's End (*stage 1*). *First tones
of shadow construction were laid in with Naples yellow, touch of rose madder,
viridian, ivory black, with a little linseed oil to help transparency. Lighter moon-
lit portions were left pure canvas.*

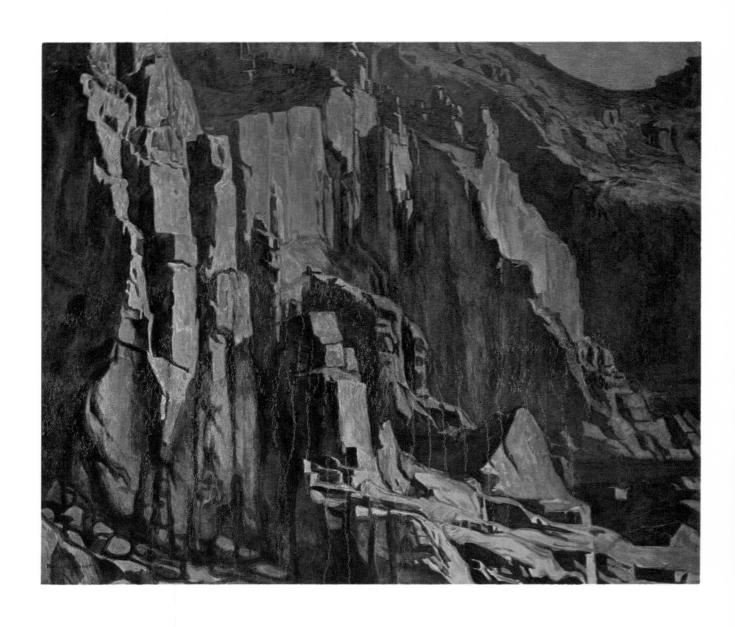

Plate LXXVIII. Moonlight, Cathedral Rocks, Land's End *(final stage) shows proper unity of tone. Portions of cliff in moonlight, left raw canvas in earlier stage, are now correct value, far easier to establish on unpainted canvas in final stage. Painting was not done on location by moonlight, but in studio from notes in black and white and color.*

PRACTICE IN SKETCHING

In connection with this demonstration, I want to stress the point that you should do plenty of sketches of waves breaking or moving directly towards you. Although they provide fairly difficult problems in drawing because of their foreshortening, as compared with more or less easier side views, their pictorial qualities make it absolutely necessary for you to master the form. The black and white medium, or even the note of colored chalk added, is of special value in this respect. It paves the way to the technicalities of full color in painting. The colored chalk note in Plate LXXII shows the feeling of weight and foreshortening in the water. Your flowing brushwork in a color sketch later will echo the lesson learned in the sweeping chalk line method.

STRENGTH AND PURITY OF COLOR

You may have noticed that the only allusions I make to flake white in the demonstrations are in relation to painting of the shadow and sunlight of the foam; the pure foreground water; and the highlights on the rocks. Flake white has the effect of not only reducing the power of darkness of pure color from a tube, but it also reduces its transparency.

Strength, purity, simplicity, and dignity of color are needed in a seascape. The idea of my simple selection is to help you to keep from floundering in a lot of unnecessary colors, and ultimately to bring a quickening of the color instinct necessary to a good picture.

ROCKS FIRST, SEA NEXT, SKY LAST

Note that rocks are painted first, the sea next.

In any picture where the horizon is fairly above the middle of the canvas, I paint the rocks first. Next, I put in the sea, as I am able to compare the strength of color in the water with that of the rocks as in nature. The same applies to the sky, which, as a rule, is left to the last. I note, for instance, how much lighter the sky on the horizon is compared with the sea and *vice versa*. So that when the relative values of rocks, sea, and sky are thus treated in their proper harmony the result is a blending of tone.

If this procedure is reversed, and the sky is painted first, say in too light a color, then in order to keep my sea in proper relationship, that too will have to be correspondingly light in tone, and so also the rocks. The result may be good as a tone picture, but I feel it would lack the character and strength of the scene.

BEST LIGHT FOR WORK

Apart from my previous advice to paint cliffs on a sunny day, so that the shadows help you constructionally, I would like to impress on you again, in the early stages, to try to choose your time for painting out of doors when the sun creates a side light on your subject, principally in sea work when the foam of breaking waves is influenced by cast shadows. The bigger masses, thus emphasized in a side light, will lead you to a simplicity of outlook, and tend to make this subject easier to study.

While I am on this point in regard to outdoor painting, I advise you not to work with the sun on your canvas, and it should not be on your palette if it is possible to avoid it. Sun glare is not only conducive to eye strain, and eventual lack of concentration, but you get your color values wrong. Your work will look different as soon as you take it indoors. After all, you don't hang your pictures in direct sunlight in a room. I have noticed that artists who paint too much with direct sunlight on their work lose a certain color sense, and their pictures react with a very unpleasant purple quality of tone.

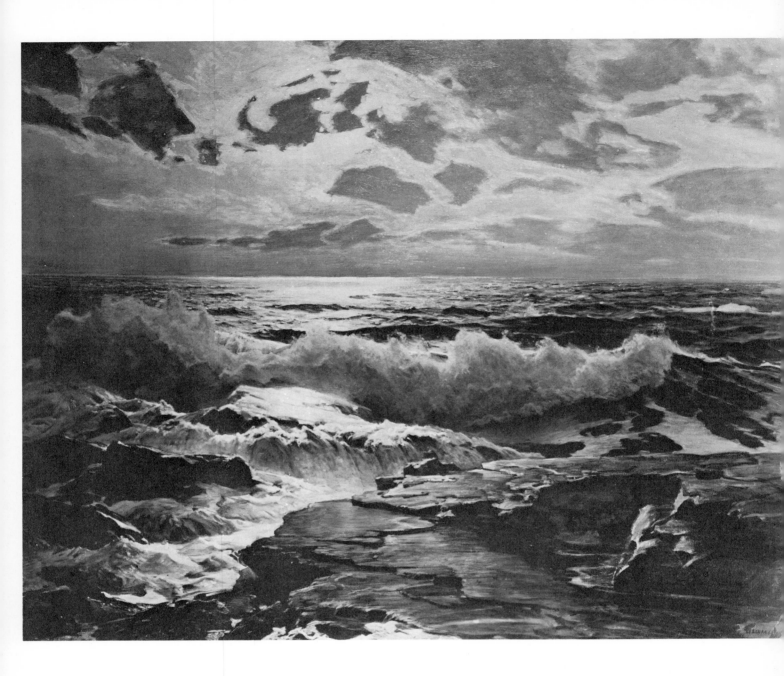

SHORES OF GLOUCESTER by Frederick J. Waugh, 40″ x 54″. The most striking lighting effects, and those that do most to define form, happen early in the day or late in the day, when sea and shore are lit from behind and slightly above, or from the side. On the contrary, midday light tends to diffuse form. In this vibrant painting, the light source is behind the clouds, throwing them into dark silhouette and emphasizing their jagged forms. The brilliant light then moves across the sea, throwing the waves into shadow and lighting only their upper edges. The path of light is picked up by the brilliantly shining top surface of the rock against which the dominant wave breaks; thus the focal point of the picture is established. The path of light then moves along the path of foam, diagonally to the left toward the viewer. The shining surfaces of the wet, flat rocks nearest to the viewer are particularly striking. The rocks are rendered with highlights, middle tones, and darks, while the shadow sides of the rocks are reflected in the lighted surfaces. Such violent contrasts of light and dark would be distracting if the artist had not placed his brightest lights with great care, to form a precise path for the viewer's attention to follow. (*Courtesy, Grand Central Art Galleries, Inc., New York*)

11 PAINTING MOONLIGHT EFFECTS

Moonlight is one of the most wonderful phenomena in nature, from an artistic and pictorial point of view. Such an effect, however, demands restraint in color, and dignity in composition.

EARLY STAGE OF MOONLIGHT

It is not a scene of mere black and white. There is color in the fullest sense, but muted in tone. The light from the moon being a reflected one, its intensity is correspondingly diminished; hence the mutation of blended tones. Moonlight on the coast is romantic and full of poetry. To appreciate and express this fully, much observation is necessary. The early stages of the harvest moonrise in August can be painted direct from nature in certain districts, as there is plenty of daylight left in which to do so. The effect of this moon rising at sunset, with the sun's glow reflected on the low atmosphere beneath it, or on any clouds which may be passing at the time, is a sight that compels a sketch.

The sky takes on an added feeling of space, which the size of the moon, magnified by the lower atmosphere, fails to diminish. I have noticed particularly the effects in St. Ives Bay, Cornwall, the topography of which adds character to such moonrises. When the orb appears above the distant hills (in the autumn especially) the warm air from the dunes and the atmosphere over the distant tin mines of Redruth gives it a coppery tone. As it rises sufficiently above the land to cast its reflection clearly, the sea near the far shore becomes ruddy in color, and the path of light, as it approaches the foreground, is of a golden quality. The more emphatic contrasts in light and shade and color take place in the path of the reflected light. The sea spaces to left and right are quieter in tone and form, and this adds space to the scene. (See Plate LXXIII.)

With the deepening of twilight, there will be no more light left to paint by. The natural concentration of direct moon rays on the water, free from the competitive afterglow, opens up the more positively pictorial aspect of the second stage of the rising. A picture of it must, of necessity, reflect a color scheme in harmony with the spirit of romance and poetry. It is not enough to paint the complete scene, say, in ivory black, cobalt blue, and flake white. Such a palette is limited in expression, and the result, however pictorial, is suggestive of illustrative work in monochrome. Too much monochrome produces a negative result. The search for true color values reacts in a positive sense.

TRAINING MEMORY

Memory, backed up by keen observation, is the forerunner to this, and not drawing on one's imagination. The committing to memory and the subsequent reproduction of even one true tone of moonlight color is an achievement worth many hours of patient observation.

I may give you the names of the colors I used for my illustrations on this subject, but they are not infallible. I just want you to carry on where

I left off, and perhaps see a little more in moonlight than you did before. It would be as well for you to note individual portions at first and memorise them, working them out at home one bit at a time. Much useful work can be done by experimenting with various blendings of color, reflective of the special portion you have observed. Concentrate on a given bit, as, for instance, the wonderful play of light on the shallow water and foam at the edge of the shore, to the elimination of all other details. A memory sketch of that portion will be of great help. (I need hardly mention that your sketch should be done as soon as possible, while the point is fresh in your mind.) Other component forms and their color notations can be studied in succeeding evenings.

It will be an aid to concentration if you cut an opening out of a bit of cardboard, and hold the card with the space sufficiently close to your eyes for the border to mask out the parts superfluous to the ones you are observing. Your forefinger and thumb can act in the same capacity.

This is a reiteration of my former advice. But, in this instance, make mental notes of the various portions, so that you may become familiar with all causes and effects.

This knowledge and experience of the various units will help you to arrive at a generally satisfactory conclusion when attempting a coordination of the scheme of which your studies were a part.

LATER STAGE OF MOONRISE

My illustration of this later stage of a moonrise represents an attempt to convey to you, on simple lines, the general idea, aided by a modest choice of colors responsive to a summer night effect.

I did not show the moon in Plate LXXIV as there was enough pictorial quality in the sea alone. But the cloud creates the illusion without my having to resort to the obvious. The shape of the cloud leads the eye to the center of wave interest, as shown in the composing lines in Fig. 22. To insure the relative tones of light being correct, as the waves recede in perspective, remember that they become smaller to your eye as they do so, and their reflective power is lessened. The crescendo of light increases as it approaches the foreground, until the sparkle on the nearest wave is as intense as the light of the moon. You will thus keep your reflection flat on the sea, and obtain the proper feeling of distance and recession. The glitter of the water may be emphasized by a slightly darker tone of sky color (which must be carefully painted) under the moon, between it and the sea. Shadows on any cliffs at this portion may be found to be slightly deeper in tone. A cloud passing under the moon intensifies this effect, as the light throws its shadow downward and creates a wonderful depth of tone.

The illustration of the first color tones (Plate LXXIV) was painted with Naples yellow, viridian, a touch of rose madder, ivory black, and a very little flake white. You will observe the "accidents" of color mixing are taken full advantage of. Moonlight shadows must be luminous. The deepest shadow can be likened to the density of black velvet, which has a bloom on it, comparable with, say, a pool of the blackest India ink. The shadows may be dense, but they certainly are not black. Test this for yourself on a moonlight night by holding up a black object in front of the scene and noting the luminosity, or bloom, of the shadows.

The second and completed sketch (Plate LXXV) was merely an intensified tone of the same colors. Again, I left the canvas bare where the pure lights were to come in the first lay-in, so that my touches of golden light (rose madder and Naples yellow) on the raw surface were clean and responsive—what some artists describe as "snappy"!

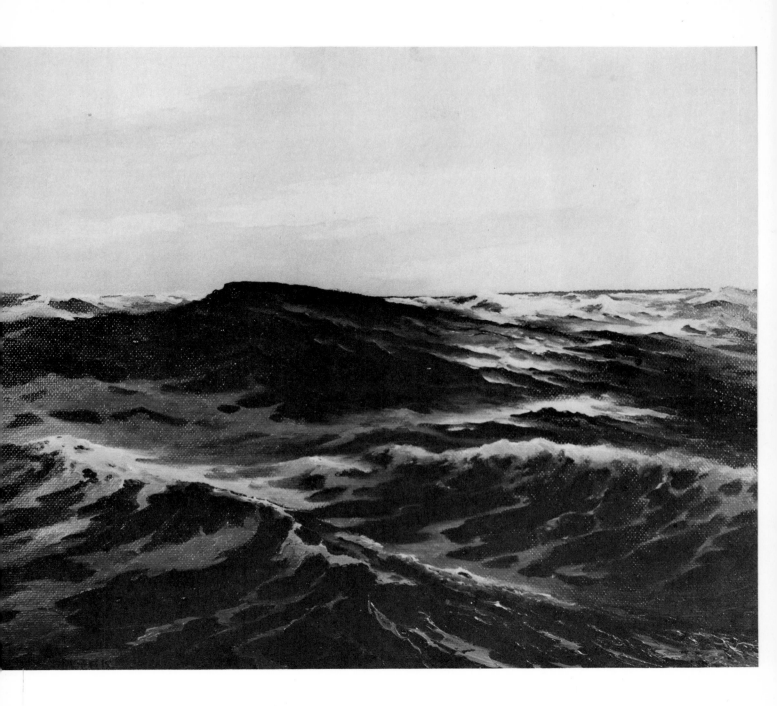

HIGH SEAS AT SUNSET by Charles S. Marek. In this extremely simple, yet effective open sea painting, the artist has chosen a single dark wave as his focal point. Across the horizontal line of the horizon, a single dark wedge shape breaks into the light sky. The viewer's attention is carried upward to this center of interest by the diagonal movement of two foreground waves and the very subtle diagonal movement of the streaky clouds. The eye is carried diagonally upward by a path of foam, which is kept from dominating the picture by being caught in a shadow cast by the dark wave. The slightly concave shapes of the foreground waves are indicated by the curving trails of foam that trickle down the sides. This painting is an important lesson for the reader: the artist has demonstrated that an effective sea piece can be created without breaking waves, billowing foam, or a moody sky. (*Courtesy, Grand Central Art Galleries, Inc., New York*)

Fig. 22. Main compositional lines of Plate LXXIV.

Fig. 23. Main compositional lines of Plate LXXVIII.

CLIFFS BY MOONLIGHT

My last picture shows cliffs by moonlight. These, in particular, are the wonderful Cathedral Rocks at Land's End. I was so impressed by the effect that I first made a careful chalk drawing on toned paper of this extraordinary formation by daylight (Plate LXXVI). The drawing reproduced shows the buttressed supports to the main cliff forms. By this means, I became familiar with the character of the cliff, and tested this particular viewpoint as a suitable one for a properly composed oil painting. I noted a certain amount of empty ground on the left of the drawing on completion, and a lack of foreground support to the mass of the cliff. The rocks at the foot of the slope below me seemed to provide the solution to this emptiness.

Proceeding downwards, I found the proper foreground in keeping with the character of the background.

The rough-in composition (Plate LXXVII) shows the main lines of construction for the oil painting reproduced in Plate LXXVIII.

The additional buttress formations in front only served to simplify and emphasize the dignity of the bigger mass. Not a single portion was out of harmony in nature's design.

The first tones of shadow construction were laid in with Naples yellow, a touch of rose madder, viridian, and ivory black, with a very little linseed oil to help transparency. The lighter portions of the cliff in strong moonlight were left pure canvas. This, of course, enables you to tone your final light parts to the correct value. And this especially applies to the sky space when painting in the proper density there, so that the eye is kept focused, as it were, on the "story of the picture."

I must add, of course, that the painting was not done by moonlight. It was the result of notes in black and white and color, made as quickly as possible after much observation, on my return to my lodging, while the subject was fresh in my mind.

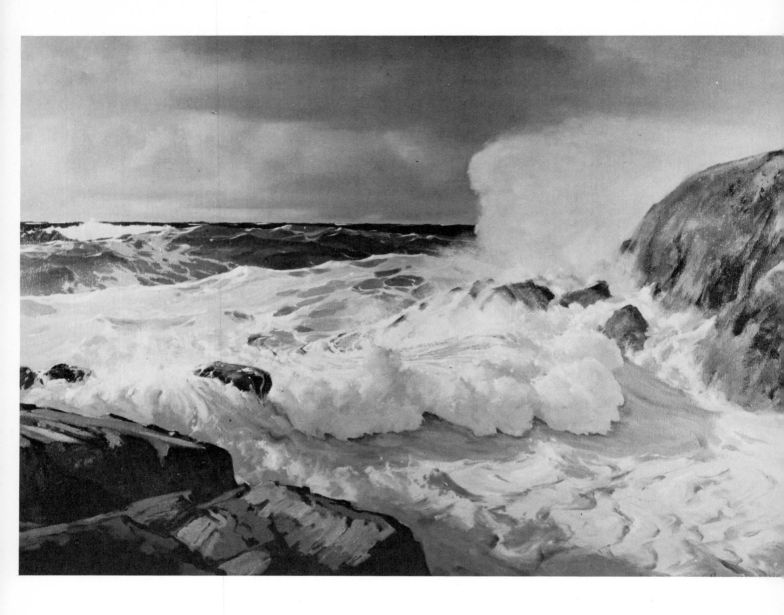

ETERNAL SEA by Rockwell Brank. The seascape painter should learn to visualize a breaking wave not only head-on, but from a side or three quarter view. Here, the painter has chosen to look at the wave at an angle which shows not only the breaking foam, but also the pattern of the top of the wave behind the foam. See how long, rhythmic lines follow the form of the wave as it curves over and breaks into foam. The wave appears to swing around the rock formation and then break, rather than rush straight in from the sea. The whiteness of the breaking wave is dramatized by the darkness of the waves behind. It is also important to remember that the sea is often darkest at the horizon and appears to grow lighter as it approaches the viewer, which is precisely the opposite of the atmospheric perspective one sees in landscape, where distant objects become grayer and less distinct. Behind the large foam shape, the sky darkens momentarily to stress the whiteness of the foam. *(Courtesy, Grand Central Art Galleries, Inc., New York)*

12 PROPER FRAMING OF A PICTURE

This note is devoted to the subject of picture framing, which has an important bearing on the complete presentation of a picture, and has been written to stimulate interest in an artistic necessity that is an all too long neglected part of art training—the choice of a suitable frame: that is, a frame that harmonizes in tone and in design with the character of the picture for which it is intended.

Certain works usually stand out with definite artistic value, even during the period of early training of the young artist. These may ultimately be judged worthy of a frame. It is just as well that, in the early stages, some thought should be devoted to this matter, so that the artistic mind can become tuned up to appreciate this last stage, and its direct consequences to the picture. Frames are the windows of the home through which the beholder views nature as represented by the pictures enclosed in them.

The windows of a house should be in proportion not only to the particular frontage, but to the size of the rooms. The framework of a window should also be of some esthetic value, so that, while a view may be admired through it, the framework may act as an appreciable factor as a setting. These principles can in a general way be applied to the framing and hanging of a picture.

EXPERT HELP

The choice of frames, while depending on the individual selection and temperament of the artist or purchaser, provides an interesting subject for consideration. No laws can be laid down as to how a picture shall be framed because of this varying individual taste. It is interesting to note, however, that the art of the framer has been brought to such a pitch of perfection in these days that some firms have earned the right to act as advisers as to how pictures *should* be framed. This is most helpful to those who cannot visualize the final effect when a sample piece of moulding, or a mitred corner, is held against the canvas. I know of one or two firms in this respect with whom artists can leave their pictures with the confidence that the final result will be all that can be desired. Their experience is of great service to the artist.

It must be admitted that the question of expense is an important factor. But there is a variety of mouldings on the market today of high artistic and distinctive quality, and at a price within the reach of even the limited purse of the majority of artists.

There is definitely no excuse, therefore, for a badly framed picture. The astonishing thing is that so many artists seem to feel that their responsibility ends with the last stroke of the brush, when signing their work. At least—and I speak as one who has been on many adjudicating committees in the art world—that has been my experience. Pictures are sent or submitted to exhibitions in frames that merely happen to fit, no matter how unsuitable to the particular work.

A picture is a decoration based on the lines of composition in nature. This is especially so in seascape painting. Such subjects should be framed in a *receding* moulding (Fig. 24). That is to say, the relief is highest near the picture, and gradually falling back to the outside edge. The tendency is to throw the interest of the work forward, and, most important of all, it eliminates heavy cast shadows on the walls of a room or gallery! This is especially helpful in the ordinary home, where the lighting is from the side. The type of moulding with the recession towards the picture (Fig. 25) may look well, *consistent with good hanging*, in a gallery, because of the likely juxtaposition with other similar frames.

Fig. 24. Best moulding for home display.

Fig. 25. This moulding produces heavy wall shadows.

In the home, however, cast shadows, especially under artificial light, should be eliminated as much as possible. In this respect, picture hooks should be placed as near the top of the frame as possible, to keep the picture flat against the wall. The result will be a more dignified and restful wall filling. It will also tend partially to eliminate reflections in the glass.

One sometimes sees pictures hanging where the hooks have been placed one third the distance down the frame. The work, responding to its center of gravity, pitches forward and looks as if it were falling off the wall (Fig. 26). Glazed pictures so hung tend to reflect the objects in a room, especially under artificial light.

Fig. 26. Shadow causes distortion of picture and wall space, caused by badly placed picture hooks, too far down.

There are firms today which specialize in mouldings modeled and colored to harmonize with any type of picture, and they are not expensive. A frame can certainly make or mar a work. It can prevent its acceptance in an exhibition, and certainly has an effect upon a purchaser. It is not every patron who is prepared to reframe a work of art at his or her own expense. It is interesting to note that in the days of the old masters the art of picture frame making was veritably a classic one. Some of the wonderful frames produced in those early days competed in price with the pictures to be framed. The color harmony of the old masters is traditional; the frames around them are equally so. The artist of today is realizing the importance of this harmony of framing, and manufacturers have been responsive. The result is a quickening of its esthetic value to the home, and in its wider sense—to our public galleries.

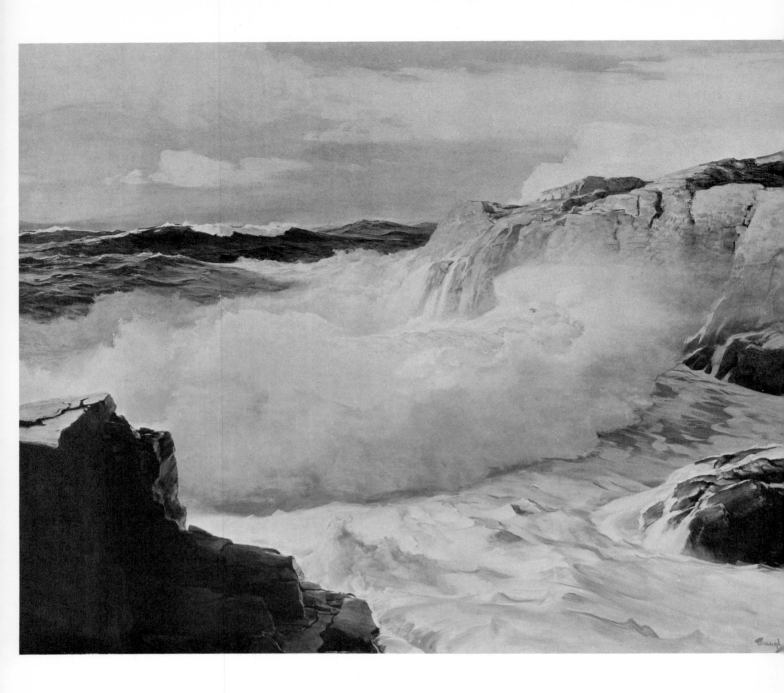

POUNDING SURF by Frederick J. Waugh, 48″ x 60″. The artist has seized upon the decisive moment when a wave explodes into foam. The whiteness of the foam is emphasized by the dark rock form in the lower left hand corner and the darkness of the sea beyond, where the waves have just begun to foam at the crest. Evanescent as foam may be, the artist has visualized it as a *form* which must be modeled with light and shade, just as a rock is modeled; the three dimensional quality of the foam shape is clearly suggested by the gradation from light at the top to darkness at the bottom of the foam, and there is even a cast shadow beneath the lower edge of the wave. Not only the water, but even the wind has a strong sense of direction: the breaking wave curves forward and pushes diagonally downward to the right; ahead of the wave, the water is rushing back to sea from another wave which has already broken; and the wind flies through the picture from left to right, catching the foam from the breaking wave and flinging it toward the shore. This wind movement is also echoed in the sea. (*Edwin A. Ulrich Collection, "Wave Crest" on-the-Hudson, Hyde Park, New York*)

CONCLUSION

Realize that you are not a photographer, but one who is striving to be an artist. A photographer gives you every detail. You will find with experience that there is no merit in painting this detail to the very edges of your canvas. The merit lies in knowing what to leave out in painting the sea. Too much detail suggests that the sea stood still to be portrayed. Your work will look petrified, or frozen, or overworked. As a simile, make your work appear almost out of focus, like movement in a photograph. Get rid of all hardness after your preliminary knowledge has taught you form and intimacy with the subject.

It has always been my endeavor to paint even large pictures out of doors. The toil of carrying such canvases, as well as materials and easel, is compensated by the freshness one gets in doing a picture first hand from nature. Naturally, a studio is more comfortable to work in, and the light enables you to concentrate more upon the work. But I feel that there is a loss of touch and inspiration caused by indoor lighting, and from the fact that you are working from sketches, that contrasts unfavorably with the freshness of outdoor work. Painting done in the open is far more luminous in tone, and this is especially applicable to seascape pictures, which must, of necessity, be translated with all the freshness and purity of your color.

I have often been asked by young beginners why the brilliancy of nature cannot be portrayed on canvas.

Painting is limited by the extent of the scientific preparations provided for you in the tubes of color. The material you paint on is also a deciding factor. Artists are always experimenting, and rightly so, to get light in their work, and wonderful effects have been painted. But nature is nature —perfect. Paint is a scientific substance made by man. If you could make a picture as beautiful or as perfect as nature, it would be a check to all further ambition. The inference is obvious. The real artist does the best he can with the means at his disposal. The finest creative work, from the days of the old masters to the present generation, in its highest sense of attainment, approaches the border line between paint and nature, because behind all this creative work is that high endeavor not only to emulate nature as an ideal pattern, but also an inspiration created by such an ideal.

So you need not be perplexed about things beyond your pigments' powers, but strive with hard work to gain experience in carrying out these traditions, and contribute your share eventually towards these ideals.

INDEX